THE OFFICIAL Vampire ARTIST'S HANDBOOK

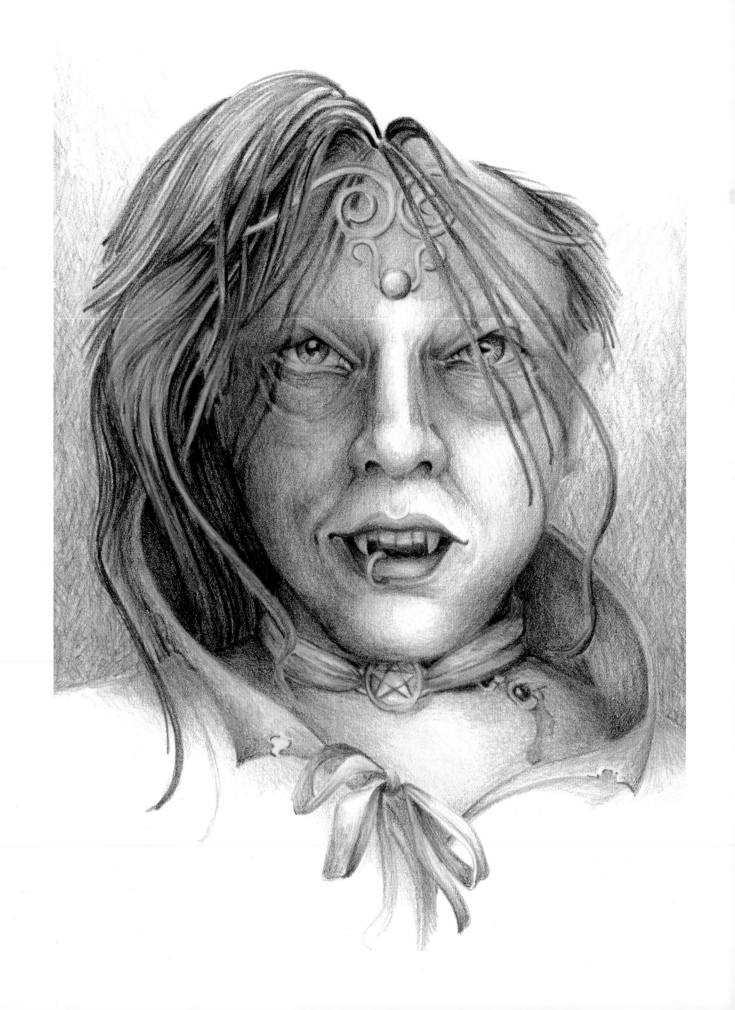

THE OFFICIAL Vampire ARTIST'S HANDBOOK

How to Create Your Own Patterns and Illustrations of the Undead

LORA S. IRISH

FOX CHAPEL
PUBLISHING

The Official Vampire Artist's Handbook is an original work, first published in 2012 by Fox Chapel Publishing Company, Inc. The patterns contained herein are copyrighted by the author. Readers may make copies of these patterns for personal use. The patterns themselves, however, are not to be duplicated for resale or distribution under any circumstances. Any such copying is a violation of copyright law.

"Vampire Facts" compiled by www.randomhistory.com

ISBN 978-1-56523-678-3

Library of Congress Cataloging-in-Publication Data

Irish, Lora S.

The official vampire artist's handbook / Lora S. Irish.

 p. cm.

Includes index.

ISBN 978-1-56523-678-3

1. Vampires in art. 2. Colored pencil drawing--Technique. I. Title.

NC825.V36I75 2011

743'.87--dc23

 2011017576

To learn more about the other great books from Fox Chapel Publishing, or to find a retailer near you, call toll-free 800-457-9112 or visit us at www.FoxChapelPublishing.com.

Note to Authors: We are always looking for talented authors to write new books in our area of woodworking, design, and related crafts. Please send a brief letter describing your idea to Acquisition Editor, 1970 Broad Street, East Petersburg, PA 17520.

Printed in China
First printing

Because making the artwork shown in this book using craft, woodworking, or other materials inherently includes the risk of injury and damage, this book cannot guarantee that creating the projects in this book is safe for everyone. For this reason, this book is sold without warranties or guarantees of any kind, expressed or implied, and the publisher and the author disclaim any liability for any injuries, losses, or damages caused in any way by the content of this book or the reader's use of the tools needed to complete the projects presented here. The publisher and the author urge all artists to thoroughly review each project and to understand the use of all tools before beginning any project.

About the Author

Lora S. Irish is the author of a series of craft, pattern, and woodcarving books including *The Great Book of Dragons*, *The Great Book of Fairies*, *Wood Spirits and Greenmen*, *Relief Carving the Wood Spirit*, *The Great Book of Tattoos*, and *Modern Tribal Tattoos*.

Working from her home studio, Lora and her husband Michael are the creators of Classic Carving Patterns at *www.CarvingPatterns.com* that focuses on online tutorials, projects, and patterns created exclusively by Lora S. Irish.

Dedication:

This is dedicated to Kent S. Irish. His enthusiasm, knowledge, and opinions have been invaluable through this project. My respect for him as a man has grown dramatically as he has offered ideas, suggestions, and critiques for each drawing and pattern to bring you the best vampire artist book possible.

Acknowledgments:

Thanks, as always, to Fox Chapel publisher Alan Giagnocavo and editorial director John Kelsey, who offer great support to my new ideas for books. Alan has always encouraged me to explore new ideas, new techniques, and new crafts, never limiting the path where each new book takes me. Fox Chapel's willingness to explore new ideas and new arts for book manuscripts has accentuated my growth as a craft artist.

Special thanks are extended to Paul Hambke and the entire Fox editorial team for their outstanding support and input.

I also would like to thank the design team at Fox Chapel—art director Troy Thorne and designer Jason Deller in particular. That team is responsible for the superb look and wonderful layout of this book.

Special thanks goes out to the sales and marketing team I work with at Fox—Cindy Fahs, Judith McCabe, and their boss, Paul McGahren. They do an amazing job. No author could be in better hands.

To Sandy Ertz, Gail Larkin, and Roberta VanOrmer, the customer service reps at Fox who never fail to greet me with a smiling voice—no matter how early I call. That is a wonderful way to start the working day.

My most lasting gratitude goes to my husband, Michael. Through thirty-three years of marriage and twenty-five years as a working team, he has endured reams of art paper, piles of craft supplies, tons of paint tubes and brushes, and a home that can smell like turpentine or linseed oil, all with a prideful delight in his wife's accomplishments. He has suffered through eating microwave dinners off TV trays because the kitchen table was full of the latest projects and through my creative tantrums when I have too many projects going at the same time.

Foreword by Kent S. Irish

Dr. Carl Jung, the well-known psychoanalyst and philosopher, was of the opinion that the social human psyche was in possession of pure characterizations known as archetypes. He found that many of these characters existed in all societies and while the minutiae may have varied from continent to continent and over time, the essence of these characters remained faithfully intact to their origins. Familiar examples include the reluctant hero journeying not only to save his loved ones but also himself, the repentant sinner seeking redemption, and the fearless protagonist serving as an ideal and role model for all who hear the story. The vampire, too, is a social archetypical expression. In the vampire, we once saw the horrifying darkness of living without a conscience, emotion, or remorse.

All cultures in the world have a vampire mythoi, though looking through the lens of our modern preconceptions we may not always see these vampires at a glance. The modern vampire is well versed in all things social; he blends and manipulates with such cunning that often a vampire is indistinguishable from you or me. Beneath the trappings of modern interpretations of this ancient character, however, one aspect remains true and untainted: A parasitic nature. That is the root of the origin and evolution of the modern vampire.

In the ancient world, the vampire was remorseless, emotionless and unrepentant, taking whatever he or she saw fit with complete disregard to the cost, repercussions, or cultural mores. In the eyes of the archetypical vampire, we saw the darkest evil that could be imagined, the worst thing a person could ever be. He stood not as a figure one would aspire to emulate but a monster, living on the edges of society with no hopes of love or salvation. Not in the particulars do we see the purity of the vampire, but in the essence. The Greeks saw the vampire as a distraught woman who stole babies in the night. The Romanians saw the vampire as the cause of cattle death and the spread of disease while the ancient Celts viewed vampires as revenants who drained a person of their blood. In all vampire stories all over the globe one thing is shared in common: The vampire *takes*.

With the publication of *Varney the Vampyre* in the mid-1800s, the old vampire archetype made its way from the realm of folklore into pop-culture, and thus no longer did we foist upon him our religious fears and concerns but our social hopes and dreams. Victorian guilt and self-loathing did more to evolve the modern vampire into the Lestats and Edward Cullens than the thousands of generations of previous mythology. No longer did we look at vampires as creatures that should be condemned, but rather as reflections of ourselves. Where once there was inherent disdain for such an evil creature, we now slowly began to hope for it's moral redemption because if something so devoid of virtue could find salvation, so could we. Gradually, the vampire changed his stripes, from the archetype of evil to the repentant sinner. Similarly we saw a spirit free of the shackles of dogma, religion, or social restrictions, something every human desires at some point and in some way. The vampire was now our blood-stained hero, a human embodiment of our hopes, our fears and our angst.

In recent years quite a controversy has cropped up around what a vampire *should* or *shouldn't* be. One side rails against the other that vampires must die when a stake is put through their heart while the other screams about how powerful vampires can walk about in the light. The truth is, however, that for everyone the essential vampire is different, because we project upon the vampire our own values, virtues, and vices. There is no more singular true vampire than there is a perfect zombie or ideal ghost; the only true vampire is the one that speaks most to us as individuals. For Anne Rice, the vampire was sexual and cunning, for Bram Stoker a horrifying visage of a life lead in the absence of morality, for me the vampire is the expression of absolute freedom at a cost of our humanity.

As long as human culture grows and evolves, so, too, will the legend of the vampire. One hundred years from now, he may be completely different, or he may have regressed to his origins as a monster; stakes may kill him or they might become his favorite entrée—we have no way of knowing. One thing is sure however: For every author and reader, every hope and fear, for every artist there will be a new vampire; he is a shadowed reflection of who we fear that we are and who we desire to be.

In this book you will find the general guidelines of what vampirism looks like, and how to bring that look into being. You will also find a great deal of flexibility and open options from which to choose. Pick those features that best suit your vision and leave the rest; or like so many others before you, express your own personal view of who and what the vampire is. There is no right or wrong way to express yourself and this book stands as a testament to that fact.

Above all have fun, for art without fun has no beauty.

Kent S. Irish

Table of Contents

Patterns

How to Foster Your Inner Vampire Artist:

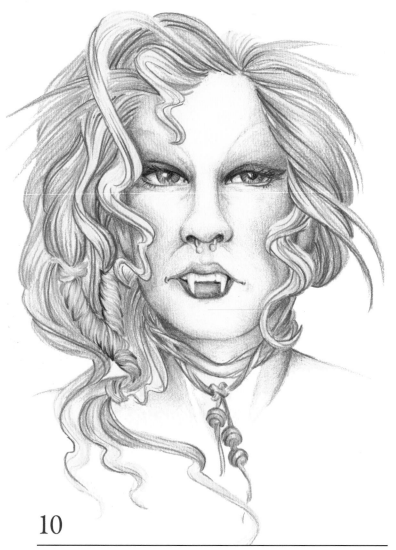

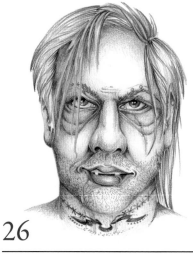

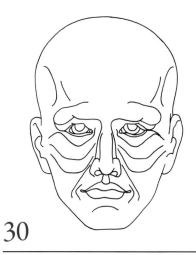

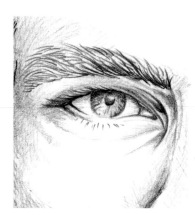

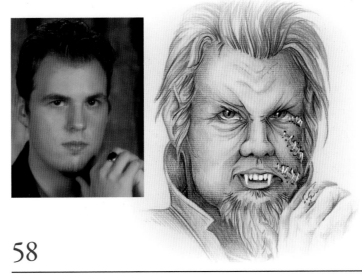
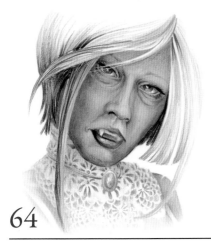
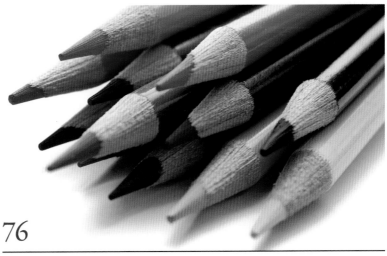
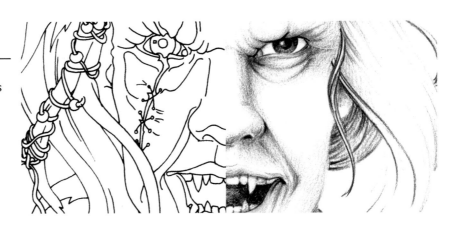

Knowledge Base for Drawing Vampires

I began my research on vampires with a list of questions I wanted to answer. There is a vast amount of information available today and it falls into three categories—mythologies, popular legends, and scientific facts. As an artist, I believe that knowledge is the foundation for good art. *Know Thy Subject* has long been my mantra. Sorting fact from fiction became my first priority.

Mythologies. Long before common man learned to read and write, the stories of our lives were passed from one generation to the next through oral history. Those who carried the memories through story telling were honored members of the village, tribe, or family as they shared with us the collected knowledge that we, as a society, needed to survive and prosper. The oral histories that endured the test of time, retold generation after generation, were those that focused on tragedy, horror, and unexplainable mysteries.

The mythologies about vampires began long before written histories. Unfortunately for someone researching vampires, the stories have become distorted through the process of passing from one generation to the next. The original facts become slightly changed with each new teller, the names of those involved become lost, and some parts of the event seems to diminish or magnify depending on the current situations of the time period. The tales even change due to the natural evolution of language.

OPPOSITE: A classic vampire scene, *Cold Stone* shows the implied story that a handsome, young, aristocratic appearing vampire has been able to lure an unsuspecting, innocent peasant girl to his stone tomb.

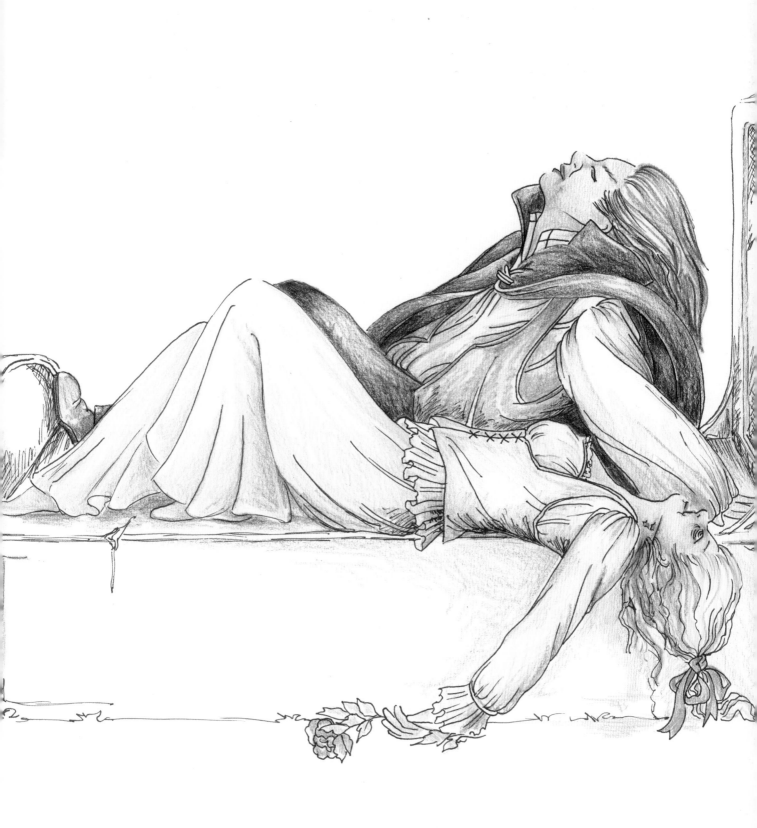

The myths and oral histories show vampires have existed since the dawn of mankind. The core emotions at the center of the stories remain intact—horror, terror, panic—that surround the unimaginable deaths within the village. The tremendous fear and grief of those who survived remains, but the facts of the original events can no longer be traced to a specific time or place to become a provable, documented event.

Popular Knowledge. Popular knowledge comes from day-to-day personal observations. As an example, everyone knows the sky is blue. I must also report from first-hand knowledge that the sky is pink, red, orange, and yellow at sunrise and sunset, it may become dark blue or green during storms, and at night it can range from coal black to shades of deep purple.

Just as unreliable as mythologies, popular knowledge changes from person to person. What one person does or does not perceive can be very different from what another has experienced. Many would totally deny the existence of vampires because they have no personal firsthand knowledge. Not having seen a vampire, their popular knowledge can be quite different from someone who has survived a bloodsucking episode.

There is a great deal of conflict within the popular knowledge base for vampires. Some report viscous attacks by mindless demon-like unidentifiable corpses where others report watching a loved one that they recently buried lurking in the dark corners during the black hours of night. A few even tell of the kind, loving, and caring nature of some vampires dedicated to the protection of mankind.

Scientific Fact. Scientific fact tells us that the sky or the air in the sky has no color. The sky appears blue because the light waves from the sun strike air molecules or dust particles, fracturing the light spectrum and allowing most of the longer color light waves to bounce off the atmosphere. The blue light waves are not become reflected and reach our eyes. So the sky is not blue, the light waves from the sun that are able to reach Earth are blue. Experiments established within a controlled environment can be conducted repeatedly producing the same results and therefore prove the facts that surround an event.

There are few scientific facts within the field of vampire research. It is shown and proven that some corpses do not decompose and remain fully identifiable and intact long after burial. Village officials and well-educated men document mass murders and clusters of unexplainable deaths often after a suspected vampire has been reported.

Much like a hurricane, the aftermath of a vampire's attack can be seen and studied but few scientists have either been on hand during an episode or survived an episode in a living state to verify the facts concerning vampirism. Just like the Yeti, Sasquatch, or Abominable Snowman, the precious few bits of evidence that have been discovered are not enough to make any conclusive determinations.

vampire facts

There are many terms for vampires found across many cultures. Some argue the word vampire comes from the Hungarian *vampir* or the Turkish words *upior, upper,* or *upyr,* meaning *witch.* The word may also come from the Greek word *nosophoros* meaning *plague carrier.* Another potential source is the Serbian word *bamiiup* or the Serbo-Crotian word *pirati.* The multitude of potential sources suggests vampires are embedded in human consciousness.

Dundes, Alan. 1998. *The Vampire: A Case Book.* Madison, WI: University of Wisconsin Press.

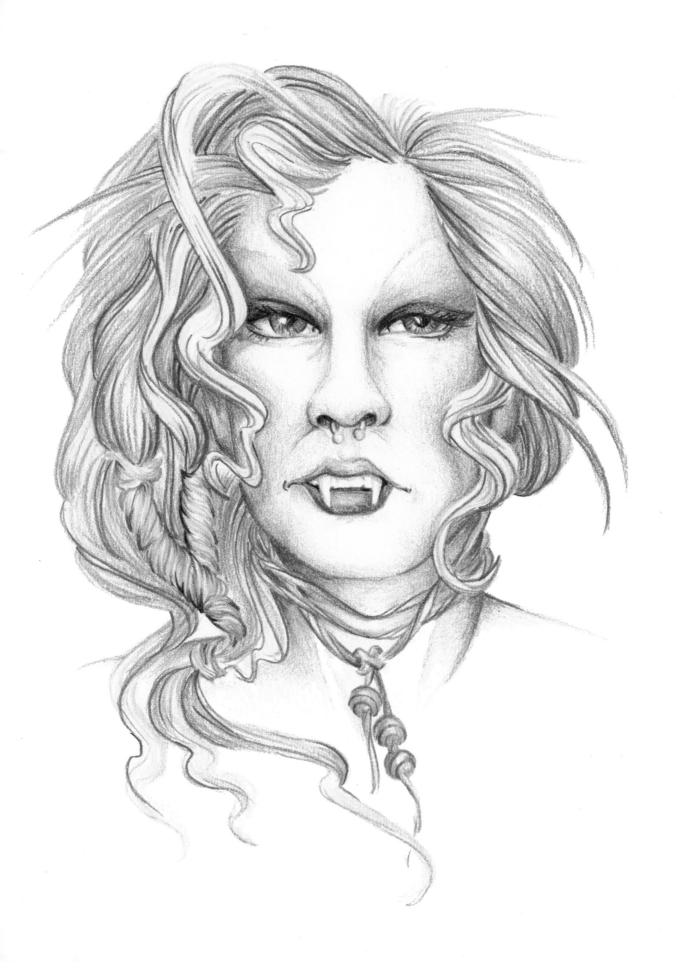

14

Questions to Ask Before Drawing

Answering the questions I had about vampires became as confusing and contradicting as trying to answer the simple questions of "why is the sky blue?" Many of my questions only lead to new questions. Many of my questions remain unanswered and many of the answers I found were quickly contradicted by the next history, mythology, or movie I researched. To some questions I found a dozen answers each different and unrelated to the others.

Throughout this book, I will share with you the questions I had about vampires. I am also sharing the few opinions, ideas, and conclusions I reached based on my research. Your conclusions may be far different from mine and you may have the answers to many of the questions I was unable to specifically answer. With or without answers, all of my questions are listed with the hopes that you may use them to guide you in your vampire art.

(The opinions and observations shared within the covers of the book are only my thoughts on the subject of vampires and do not represent the opinions of my publisher or any other entity, and may differ dramatically from your own conclusions.)

In the matter of art, art patterns, and design I can and will be specific. Basic art design concepts do have definable rules. So where I cannot tell you for certain where and how a vampire's face becomes scarred—what action or process is involved—I can tell you how to place the scar on the face, how to distort the facial features to adjust the face for the scar, and even how to create railroad track stitches to hold the physical sides of the scar into position.

OPPOSITE: *Pretty in Pink* is an example of the alluring nature of some vampires.

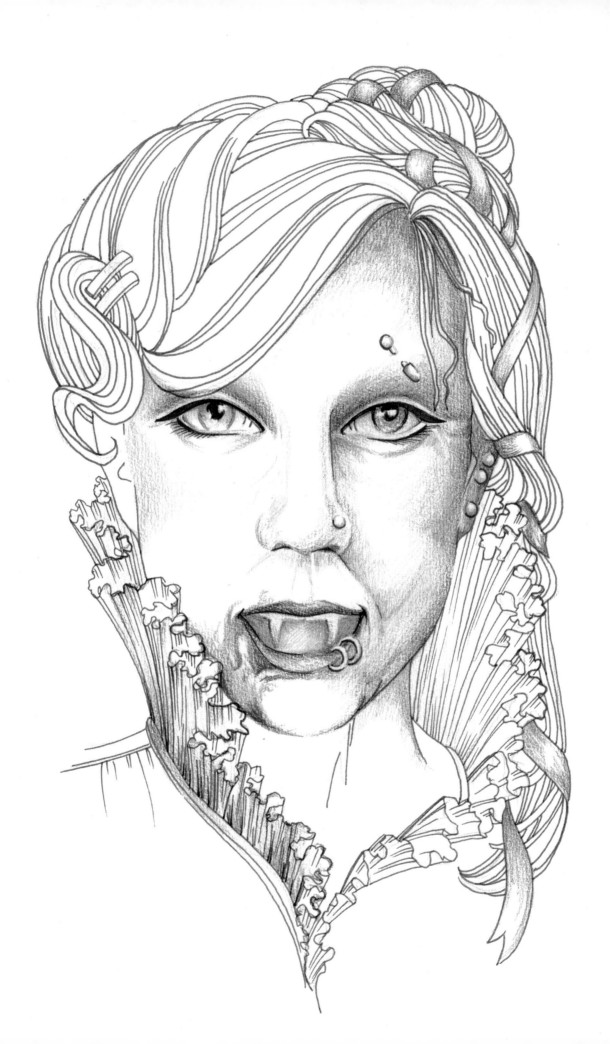

Questions

1. When did vampires first appear?

The drinking of blood and sharing of blood goes back to man's earliest recorded history. The term *vampire* was first documented in the eighteenth century in a 1734 travel guide published in England titled *Travels of Three English Gentlemen*.

2. Which vampire is the most important to understanding vampirism historically?

In my opinion, it is Arnold Paole, also known as Arnont Paule, a Serbian who died in 1726 and left behind the most convincing evidence of vampirism. Paole believed he was being stalked by a vampire and had contracted vampirism. His account states that he cured himself by eating the dirt from the vampire's grave while smearing his own blood across his body. About one month after Paole's death, several people from his village reported being stalked by Mr. Paole. All of the reporters died within a few days. In total, an epidemic of at least sixteen people fell victim to Paole. Upon exhuming his body from the grave, some forty days after his death, the village officals found his body intact and without decomposition, his eyes and nose filled with uncoagulated blood, and his burial clothes bloody. To ensure no further nuisances from Paole, town officals drove a stake through his heart. Obviously Mr. Paole's dirt cure did not work!

3. Are all people who bloodlet, share blood, or drink blood vampires?

No. The Masai tribe in Africa drink a mix of cow's blood and milk, Christians symbolically practice blood sharing and blood drinking in their ritual of Communion, and bloodletting has been a common medical practice as far back as the Greeks.

4. Do all vampires drink blood?

All vampires do drink blood but not all drink *human* blood. Some, because of a pecularity in their personalities, chose to abstain from hunting humans and instead use blood obtained from a slaughter house or from the local blood bank depository. There are even reports of vampires who become emotionally attached to one living person and will only feed off the blood of that loved one.

5. Which historic vampire is the classic architype?

There seems to be no archetype for the vampire species beyond their physical need to drink blood. Even the state of each vampire—living, dead, undead, or living dead—seems to be a changeable attribute. Every vampire seems totally unique.

6. Are there animal vampires?

We all know about vampire bats that inhabit Mexico and South America. We can also include leeches, fleas, mosquitoes and bedbugs. Piranha fish are not included in this list as they are meat eaters and blood is a secondary diet.

7. Can all vampires turn into vampire bats?

It appears there is one small subspecies of vampires from the direct line of Dracula that have the power to transform into vampire bats. There are reports that some more modern vampires can transform into rats, frogs, flies, and even roaches .

8. Who is the most famous vampire?

Bram Stoker's *Dracula* would be on the list, as would Valdimir the Impaler. In my research, it appears the number of famous vampires dramatically increases with human literacy, the printed book, movies, and now, television.

9. Are there special attributes for vampires associated with specific stories or stories from specific geographical areas?

It seems that each new story from one area or region will have similarities. As time progresses, each new vampire in the region appears to develop stronger, more devastating traits or even add new traits to their character.

vampire facts

Vampire groups have variously been called a clutch, brood, coven, pack, or a clan.

Melton, J. Gordon. 1999. *The Vampire Book: The Encyclopedia of the Dead.* Farmington Hills, MI: Visible Ink Press.

10. Are there basic physical/behavioral traits to historic vampires?

The earliest histories prove vampires did not decompose after death and burial. In fact, that lack of decomposition appears to allow those living humans who encounterd a vampire to identify them by name, implying they still had very recognizable features. Modern vampires range from scar ridden, boney-browed, demonic monsters, to extremely beautiful picture-perfect humans.

11. Who is the typical victim of a vampire?

It seems there is some basis for a vampire's victim choice but I cannot find any specific details to how that decision is made. Each vampire has his or her own personal preferences.

12. Are victims chosen by age, occupation, social status, sex, or any other specific trait?

Except for simple ease and convenience of the victim to an extremely hungry vampire, victim traits seem to change depending on the species of vampire or the vampire's geographical location. Obviously, urban vampires have a wider range of victims than rural vampires and so can be more particular in hunting out certain victim traits. The few traits that seem to be repeated in the histories include a certain sex of victim, a disease-free victim, and a specific blood type, such as O+ or AB. A few look to find enemies from their past life because it adds the joy of revenge to the meal, but the most preferred treat seems to be the blood of a virgin.

13. Are there specific feeding patterns?

In my opinion, vampires appear obsessive/compulsive in their hunting rituals. Vampires will hunt a particular area of their surroundings, at certain times of the week, at certain times of the night, waiting for a predetermined type of human to appear. A classic popular example is the hungry vampire lurking in the shadows of a college town bar on Thursday nights, which happens to be advertised as Ladies Night. This vampire might be obsessive/compulsive because he returns repeatedly in the hopes of catching a beautiful, young, virgin, intelligent, educated human female. It may be that vampires repeat specific feeding patterns because they simply provide the best results. The same vampire in the example above may stalk that same college bar because inexperienced, distracted, boisterous, drunken females are easy prey.

SUMMARY LIST OF VAMPIRE TRAITS:

Physical attributes:[1]
- boney ridged brow line
- deep set eyes
- canine blood fangs
- fully fanged mouth/blood covered teeth
- oval or diamond shaped pupils
- gray, green, or pale white skin
- long gnarled fingers/long twisted fingernails
- unhealed wounds/self-stitched open wounds
- pointed ears
- blooding scars at neck, temple, or ankle
- little or no eyebrow hair/extreme uni-brows

Documented abilities:
- flight, extreme jumping
- mesmerism/hypnosis/mind control
- superhuman strength/speed/agility
- immortality or extreme undead life spans
- super human hair
- instantaneous martial arts skills
- sexual superiority
- expert in taking a human guise
- disappearing into dark shadowed areas
- acute hearing

Weaknesses and banes:
- silver
- water including pure, fresh, salt, or holy
- garlic
- sunlight/UV light
- Christian symbolism
- being blood-drained
- non-healing of wounds or amputations
- mirrors[2]
- residential buildings[3]
- revenge demons, witches, werewolves, zombies, and undead Viking kings

[1] All, some, or none of the attributes above may be applied to your species of vampire.

[2] Vampires cast no reflection in mirrors which allows humans to positively identify an entity as a vampire.

[3] Vampires cannot enter a home without being invited into that home by the owner. Public places seem to allow unrestricted access.

> **THE CROSS ROADS BURIAL:**
> As vampires die, are buried, and then rise, an ancient method to kill the rising vampire is to bury their coffin at the center point of a crossroads intersection. The vampire, escaping his or her coffin, will find himself or herself with several roads from which to choose. Being obsessive/compulsive, the vampire will be unable to pick the correct road to travel. They will find themselves still struggling to make a choice at the break of day and die from direct exposure to sunlight.

14. How does a vampire capture a victim?

Each legend has a different style of stalking from sexual allure to simply pouncing violently on an unsuspecting person.

15. Where does the vampire bite his or her victim?

Although the artery near the base of the neck seems the most common feeding spot, you will also find references to feeding at the wrist, ankle, and any recently opened wound.

16. Do vampires become more ugly and demonic after they have contracted vampirism?

That appears to be the case in ancient histories but the modern morphology is that they take on a dual appearance, becoming more beautiful when not hunting, but ugly and gnarled while hunting.

17. Are the physical facial and body changes in a vampire permanent?

Where it appears to be a permanent condition for the vampire to undergo physical changes, it also appears that those changes can alter depending on whether the vampire is hunting, feeding, or between meals.

18. What do vampires wear?

Some vampires appear trapped in the garb of the era in which they were transformed. Others seem to have an unlimited expense account and wear only the top dress designers of the day.

19. What happens to a vampire's hair?

Hairstyles seem to be part of the morphology of vampires. Some species of vampires appear to physically change from stunningly beautiful people when not hunting, to demonic monsters when hunting. During that change their hairstyles also seem to physically adjust to their state of activity.

20. Where do vampire sleep?

Some report that vampires return to their burial plots and coffins. Other tales tell of vampires sleeping in their coffins within their castles or in some hidden room of the local cathedral or chapel. One popular vampire used the sewer tunnels under his city as his home. Some modern vampires even share apartments with their beloved human companions.

21. Are vampires directly related to other demonic species?

Vampires appear to be a totally separate species to demons, zombies, witches, werewolves, undead mummies, and risen-from-the-dead Viking lords. A clear example is the observable differences between a vampire and a zombie. Zombies are obviously brainless, emotionless, reactionless undead controlled by some higher power. Vampires are cunning, slick, and well skilled in their hunting techniques; have a wide range of emotions from deep passionate love for a particular human to raging violence when hunting; and would never allow another entity, unless it was the leader of its particular pack, to control their movements or actions. The only common denominator that I could find between these different species is that they are all undead, except, of course, for werewolves and witches.

22. Are all vampires in direct relationship with demons, zombies...etc.?

Familiarity between vampires and those of demonic species is a very recent development in the vampire community. There may be more demons at this historical time and therefore there is more likelihood of a vampire/demon interaction. Perhaps it is because the rapid evolution of vampires is also happening within the demonic species making both more compatible.

23. Are all vampires cunning, slick, and well skilled?

There seems to be a general pattern with vampires that the intelligence level of the vampire while human determines the intelligence level after vampirism. Unlike physical appearance and social acceptability within their group, which becomes enhanced in modern vampires, there is little or no change in mental abilities. Some vampires are quite stupid.

24. Are all contemporary goths and witches in relationships with or to vampires?

Wearing black is often associated with both the goth culture and with vampires. Both may be from the close association of vampire stories during Queen Victoria's era and her habit of only wearing black after her husband's death. Wearing black only proves a limited taste in the individual's clothing palette.

25. Is there a hierarchy to vampire clusters?

It does appear that some vampires live or interact within a set group of related vampires. A few histories and mythologies suggest the hierarchy is determined by the order of becoming a vampire and the direct relationship to the vampire who bit you. So he who bit first is the leader of those he directly infected. Those infected by the secondary tier are socially inferior to those who bit them and so on down the line. Other groups of vampires are part of social relationships or groups, but have no identifiable reasoning to the social tiers beyond normal human groupings. For these groups, power, strength, or intelligence seems to determine an individual's ranking.

26. Do all vampires associate in groups under the "first vampire"?

Again, it depends on the species of the vampire. Some vampires do group, others seem to be anti-social loners.

27. How do you become the top vampire?

In speculation, it may be through attrition where the top vampire has been destroyed/killed and therefore the next vampire in line takes their place.

HOW TO KILL OR CONTAIN A VAMPIRE:

A few ways to keep the recently buried vampire in his or her coffin:

- Drive a stake through their heart securing them to the floor of the casket or coffin.
- Tie the vampire's body with a multi-knotted rope. The obsessive/compulsive vampire can not leave the coffin until they have untied each and every knot.
- Spread seeds, nails, or buttons on the grave dirt. The vampire, again being obsessive/compulsive, cannot leave the grave until they have counted all of the small items.
- Decapitate the vampire and turn the severed head to the floor of the coffin. The vampire cannot see his way out of the grave.
- Turn the entire body of the vampire face down in the coffin. When he breaks free he will claw out of the coffin in the direction he is facing, toward Hell.
- Place a large weight on both the belly and head of the vampire so that they cannot sit up in the coffin.
- Cast magical spells on the coffin that cause the coffin to remain sealed.
- Bury them in a lead coffin. This prevents other demonic spirits from helping the vampire escape.

How to kill a vampire that has risen

- There are several methods of destroying a vampire. The most reliable is to drive a wooden stake through its heart. Silver stakes are also used but are not necessary reliable. Decapitation also kills the vampire and is most reliable when inflicted with an ancient or magically enhanced weapon. Forcing some vampires into direct sunlight can cause death, as does showering the vampire with Holy water. The easiest method is to hire a vampire slayer or a modernized good vampire to do the task for you.

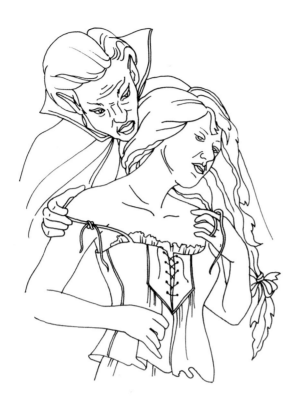

The neck is the classic vampire feeding spot.

28. Are some vampires in relationships with living humans, besides as a dinner entree?

Not in distant history, but modern vampires seem to be developing an attraction to emotional commitments with one or several humans, substituting the human group for their vampire group.

29. Is there a vampire slayer?

There is less documented information on vampire slayers than there is on vampires. Because only one slayer seems to appear each generation compared to the many vampires created within that time period, it is much more difficult to obtain concrete factual details.

30. Why are there good vampires and bad vampires?

This is a recent development that seems to be based on an underlying emotional guilt within the vampire because of the number of human victims it has taken—much like a living human turning into a vegetarian because of their deep-seated emotional concerns for beef cattle. There is also some speculation that being "turned into a good vampire" is caused by a Revenge Demon against the said vampire and done as punishment to the vampire.

31. How do good vampires manifest?

This is such a recent development, within the last two decades, that there is not enough information to create even a speculation.

32. If you are a good vampire do you always go to war against bad vampires?

So it seems. "Good" vampires also appear to seek out and destroy demons, werewolves, witches, zombies, undead mummies, and risen-from-the-dead Viking lords.

33. How has the vampire image evolved since Vladimir the Impaler's story?

Vladimir's story seems to imply he was beyond insane and close in relationship to the devil or to a demonic spirit. In fact, there is well-supported speculation that Vladimir was really a living human who used the vampire myths to further the terror of his local village so that he could indulge in his irrational violent nature. Some of today's vampires appear to have well developed social skills, a great deal of emotional maturity, and even an active social conscience. I would not be surprised if some species of modern vampires recycle their trash on a regular basis.

34. How does one become a vampire?

You can become a vampire by being bitten and drained of all of your blood. There are also tales where the vampire must take some but not all of the victim's blood, leaving the victim in the living dead stage. For some species of vampires, it takes a series of bites that remove a limited amount of blood over a period before the transformation occurs. Other histories show that the victim of the vampire must willingly bite the vampire and ingest some of its blood. Some histories go so far as to suggest there must be an equal sharing of blood draining between the vampire and the victim.

35. How many blood fangs does a vampire have?

For some it is only the canine teeth; for others it is all the front upper teeth between and including the canine. Still other species even have lower blood fangs.

36. Do all vampires have pointed "demon" ears?

Some do, some don't, and some you cannot tell because of the way their hair is styled.

37. Is vampirism curable?

Not according to the history of Arnold Paole.

38. Does everyone who is bitten become a vampire?

Some do, some do not. Some victims simply die a true and real death. Some totally recover without becoming vampires themselves.

39. What did I not find in my research?

Vampires are not European Gypsies nor do they use Gypsies as a disguise. There is little concrete information to suggest vampirism is caused by voodoo spells. There seems to be no basis for the suggestion that vampires are just demons, zombies, or direct creations of Satan.

40. When you become a vampire are you only awake at night?

In some histories, it is clearly shown that direct sunlight destroys a vampire and so they must, to survive, stay hidden in the dark shadows or only appear on moonless nights. There appears to be a new evolution in one group of vampires who can not only survive sunlight but take on a delightfully shimmering appearance when they are out and about during the day.

41. What repulses or repels a vampire?

There are some hints in the historical information that vampires avoid ill or chronically diseased humans as potential victims. There is also a hint that modern vampires with better-developed human sociology may bite a chronically ill human as a cure for that human of the disease. The once ill human now becomes a healthy vampire.

42. What happens to the undead vampire when they are killed?

Some vampires explode into a cloud of gray, volcanic-like dust. Others implode and simply disappear. Some go through a rapid aging process and then decompose into a pile of rotten flesh.

For a vampire artist, all of this means that we have a range of skin color palettes available to us for both the biter and the bitee.

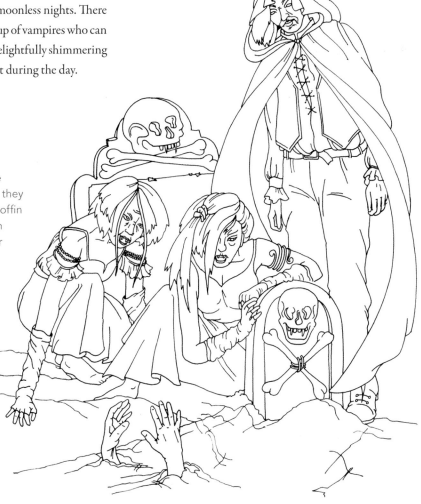

How do vampires get out of the grave once they have been buried? How do they get past the cloth and wood of their coffin to rise up? See other questions—both answered and unanswered by popular vampire mythology—throughout *The Official Vampire Artist's Handbook.*

What are Vampires?

Stories about vampires have been with us for hundreds of years, but as with the world and society in general, vampires have evolved considerably since they first appeared in our culture. Ancient vampires were actually easier for vampire artists to deal with because their physical appearance didn't change upon their conversion from human to vampire. But modern vampires have grown complicated and their associated mythology has changed. Modern vampires live openly among humans, drink synthetic blood for sustenance, fall in love with humans, and marry. It is a whole new set of rules and the rules are always changing.

OPPOSITE: *Dark Ages* shows several stereotypical physical traits of the ancient vampire— gray pallor of the skin, wild unkempt hair, unhealed wounds and partially closed scars, a blind eye, and canine blood teeth. His straw hat that identifies him as a lower-classed peasant hides his face in shadow.

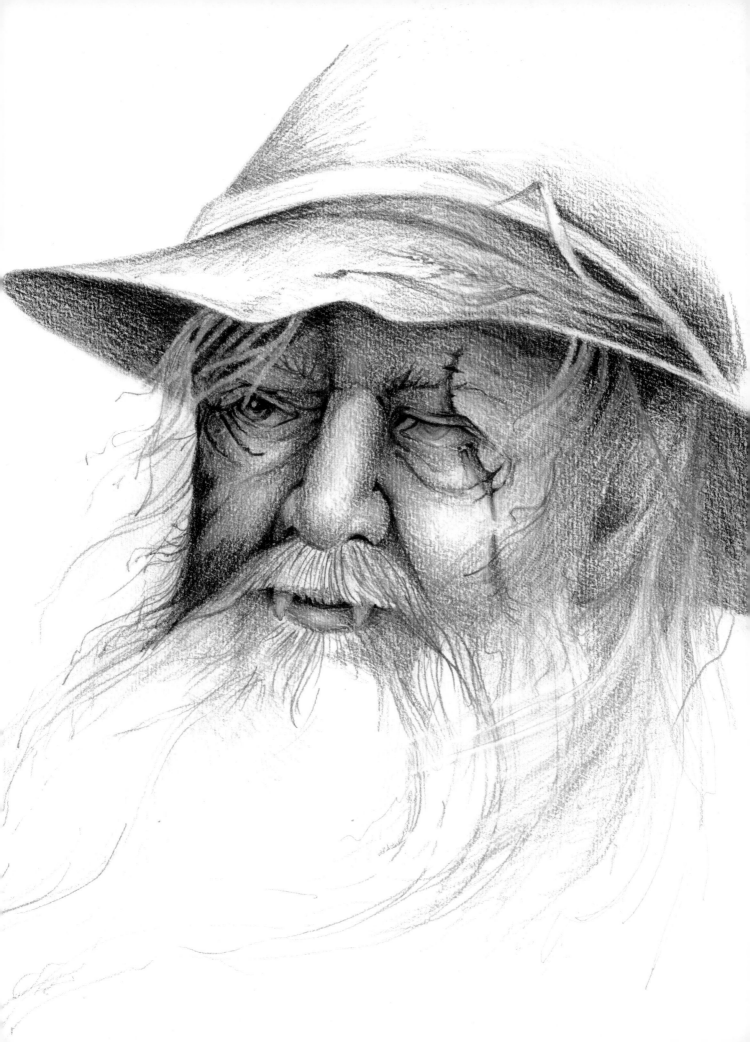

24

Ancient Vampires

Ancient vampires were much easier for the vampire artist to create because they remained in the state in which they existed when transformed into vampires. Many histories suggest they also donned flowing black cloaks with bat-ribbed collars, making the vampire easily identifiable among the general population.

Vampires of our early forefathers from Eastern Europe, circa 1734, when the word vampire first appeared in modern literature, are far different from those of today. They were more violent, trapped in their vampire morphology, and one vampire could terrorize an entire region that today would take a large group of vampires to cover. They were humans who contracted vampirism and died, were buried, and then fought their way out of their coffins to rise and walk the nights. Being undead, they did not suffer from common ailments or from old age. Various means were used to kill the ancient vampire and even more were created to trap the vampire into his recently buried coffin.

Seldom did ancient vampires congregate in groups, preferring solitary existences or only one or two companions. The first vampires did not have close loving associations with living humans; humans were strictly their food source.

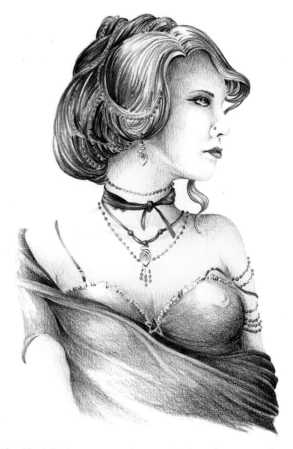

Like *Black Satin*, many modern species or subspecies of vampires have totally human looks when not in the feeding frenzy morphology. Some take on a more-than-perfect living human appearance.

Arnold Paole

When the first documented vampires appeared in the mid-1700s, it was clear the species was many centuries old. Where its beginning point in man's history lies is unknown.

Only a few living species show the dramatic evolutionary-like changes that vampires have displayed, with the greatest changes occuring within the last 400 years. One is the fruit fly; another is the virus.

Let's look at Arnold Paole, the Serbian who died in 1726. He was trying to cure himself of vampirism before his death in 1729, which means that there were vampires in his area before the first publication of the term vampire in 1734 and Paole contracted vampirism while he was still alive. His cure of ingesting vampire grave dirt while covering his body with his own blood suggests that he understood he had contracted an illness.

Based on Paole's case, I believe people become vampires because of a viral disease process. Paole's death falls in the middle of the Great Plague that began circa 1700 near the Russian/Sweden border and eventually reached Romania by 1738.

The viral influenza that hits in any given year can be dramatically different from the virus that hit in the year previous, yet both come from the same original viral source. Sometimes causing lifelong chronic conditions, viruses can effect the cell structure creating swelling, distortion of boney tissue, cancerous growths that would account for the boney browed, gnarled teeth, and skin color changes akin to that of any vampire species. Skin lesions and rabies-like madness are also common viral symptoms. Some viruses lie dormant (or latent) for many months and even years before the disease

process becomes active. During latent periods, the host can still spread the viral infection to others. Flare-ups of symptoms is not uncommon, with the human host having several months or years of normal health followed by bouts of illness and sickness.

Viral disease

All of Paole's symptoms can be explained as a viral disease process. Contracting the disease from the original vampire host while still alive, Paole seems to be in a latent or dormant period of the virus' growth during his life, and then develops full blown viral vampirism after his death.

His cure is twofold. First he eats the dirt from the vampire's grave. That dirt would have contained billions of bacteria that would have generated from the semi-decaying body of the viral-infected vampire it held. Perhaps he intuitively, as in a dietary deficiency craving, knew that the bacteria might fight the viral infection. More bacteria may have been created in the grave's dirt from Mr. Paole's own blood, which carried the virus. Unfortunately, bacteria does not destroy viruses.

The full effects of the vampirism virus does not appear to set in until one full month after Paole's death. His victims also endured an incubation time before they died of the virus.

As for the local officals driving a stake through Paole's heart to kill him in his interred coffin, there is no real evidence as to what state—living, dead, undead, or living dead—Paole was in at that time. Perhaps the stake did nothing more than firmly secure the vampire's body to the wooden floor of the coffin.

vampire facts

Vampire groups have variously been called a clutch, brood, coven, pack, or a clan.

Melton, J. Gordon. 1999. The Vampire Book: The Encyclopedia of the Dead. Farmington Hills, MI: Visible Ink Press.

Modern Vampires

Today's vampires seem to be splitting into two totally different types of vampires—those who still carry many of the earliest vampire traits as described previously and those that have become more socialized within and to the living human community. From dark, dank, blackened tombs, some species of vampires have emerged into the living community as friends, lovers, and even heroes. It appears there are even some vampires that become vampires before death, still as a living human, transforming into a living vampire.

Each group of modern vampires has different traits, characteristics, and physical adaptations than any other group. Today's vampires who fall into the second category of modernism are individually unique, varied, and seem to be evolving rapidly into more active, kind members of society.

Virus strengthens

The recent explosion in vampire evolution and changes can also be contributed to viral vampirism. As viruses mutate, some get stronger and some get weaker. Within the 400-year range between Paole's viral vampirism and today's vampires, there clearly is enough time for the human body to develop some natural immunities to the disease, weakening the effects of the viral infection. This may account for the increase in more humanly beautiful vampires, vampires that physically transform from a human appearence to a demonic appearance only during the feeding frenzy, and even the reduced occurrences of the rabies-like madness early vampires displayed.

As the vampirism virus mutates and the potential human host develops more immunities to it, the chances of developing different varieties of vampirism and different degrees of vampirism become greater. Any doctor can tell you that there are as many strains of the common cold virus as there are humans. Perhaps this is also applicable to viral vampirism—there are as many strains of vampirism viruses as there are vampires making each and every vampire unique.

26

Problems With Drawing Vampires

Several major problems for vampire artists exist within the multitude of legends, myths, and histories. As an artist, my mantra has always been *Know Thy Subject*! It is as important to understand how and why a subject works as to visually see and render that same subject. Researching your theme, topic, or subject avoids small errors that become blatant mistakes to the viewer of the art.

OPPOSITE: A basic vampire, complete with multiple piercings, tattoos, scars, and tell-tale blood.

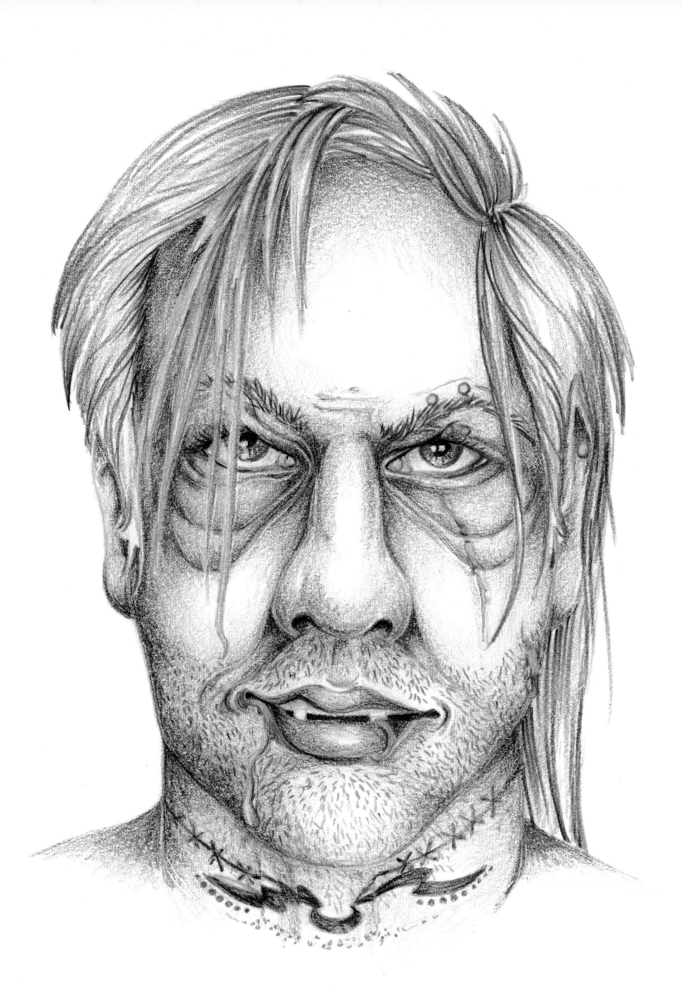

Solutions

A vampire artist needs to have a strong, solid story to create a strong, realistic painting. If the facts surrounding the original myth are unclear or contradictory, you, as the vampire artist, need to carefully consider each fact, consider possible alternatives to why the myth is contradictory, and create a solid story-line base for your drawings.

First some questions

1. Who was the original vampire that stalked and infected Paole? Where did that first vampire originate?

As an artist, I would assume one of two facts to answer this question—the first vampire must have been either a traveler or a villager who died many decades before Paole's time. Those conclusions come from the fact that neither Paole, nor any other villager, could place a name on the original vampire, yet they were able to name Paole when he arose from the dead.

2. Why was Paole the only named or noted vampire in this story? If he killed sixteen villagers after his death, why were there not sixteen more vampires at the end of the myth?

Because the story states Paole's body was exhumed and staked to prevent him from continuing to stalk the village, as an artist, I would assume all of Mr. Paole's victims also were exhumed and staked at the same time. That would have prevented any other vampire infected by Paole from rising from their grave.

Again I return to the case of Arnold Paole. He believed a vampire stalked him. The story states he was buried and then rose from his grave approximately one month after that burial. The story suggests residents of Paole's village recognized him as a vampire and several of the local populace became infected by him and then died. Forty days after his death, the town official's exhumed his coffin and body.

3. If Paole really did rise from the grave to haunt his village, why did the town officials need to exhume the coffin? Would not the grave and coffin have been already opened when he left his grave?

Obviously, the grave had been opened, the dirt thrown back, and the coffin lid opened or else Paole could never have left the graveyard. He is factually noted as being a vampire with a tangible undead body, not as a ghost that could have left the coffin without disturbing the dirt. From the story, we know there were sixteen other burials in that graveyard within a two week or less span. Obviously, the over-worked, distraught, terrified grave digger must have assumed Paole's open grave was the most recent burial and simply closed the coffin lid and refilled the grave with the dirt, so that when the officials arrived later that day, they found a closed grave.

vampire facts

Count Dracula, perhaps the most well known vampire in popular culture, quoted Deuteronomy 12:23: "The blood is the life."

Melton, J. Gordon. 1999.
The Vampire Book: The Encyclopedia of the Dead.
Farmington Hills, MI: Visible Ink Press.

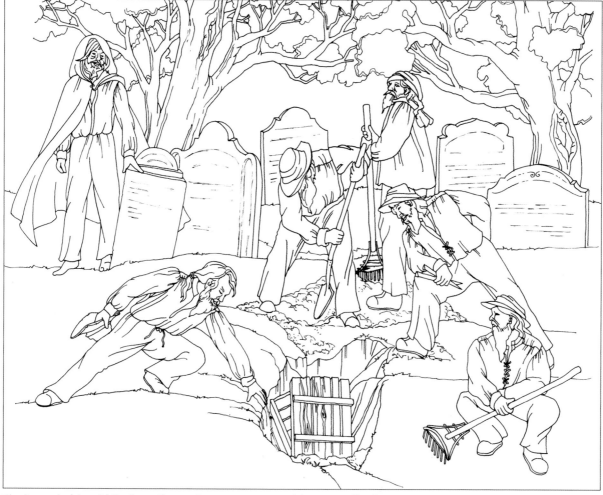

The legend of Arnold Paole easily translates into a scene of the town officials opening the grave.

Creating the story within your art

Creating a scene or drawing for Paole's story, I would show a graveyard with many recent freshly dug graves. It would be mid-afternoon or early evening to avoid the night when a vampire rose from the grave. A band of town officials would be standing around an opened grave either digging out the grave or with the grave and coffin lid open. One official would have a wooden stake and hammer in his hands and be leaning into the coffin. Several others would also be holding wooden stakes because once they are finished with Paole they have at least sixteen other potential vampires to stake. In the background,

I would place the gravedigger looking both terrified and hesitant to approach the gravesite. I would add a bloody tombstone to mark this particular grave as Paole's. A hooded monk or priest, in a position of prayer, might be added to the scene.

To add drama to the scene above, foot prints leading to and from the grave could be shown in the soft dirt of the adjacent burial sites, with multiple paths to imply the vampire made many trips to his village.

UNANSWERED VAMPIRE QUESTIONS What is the difference between dead, undead, immortal, and living dead?

Drawing the Human Face

Vampires originally had very human faces. Because of the vampirization process, the face becomes distorted with thick heavyset eyelids, ridged brow lines, vampire canine teeth, and unhealed wounds or scars. Each change is worked from the original human structure so an understanding of the basic features, shadows, and highlights of the human face creates a strong foundation for your vampire art.

OPPOSITE: Vampire artists can use the basic face of a middle-aged male as a foundation in creating vampire portraits.

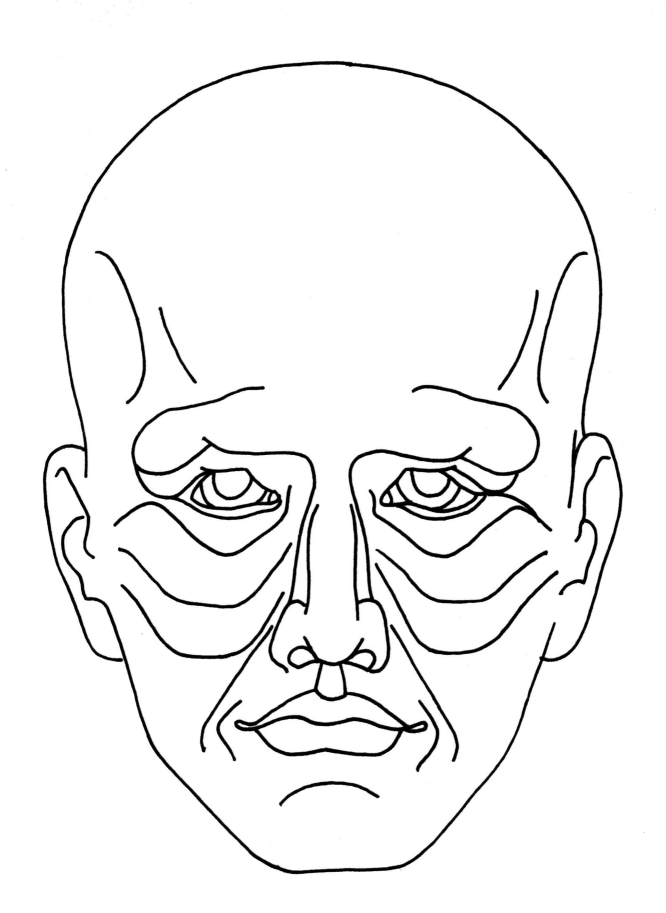

Proportions

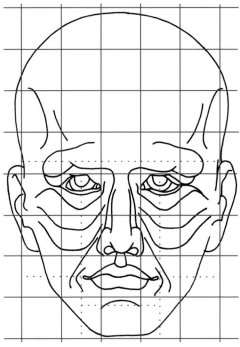

Place a grid over the foundation face to guide the placement of alterations such as boney brow ridges, blood fangs, tattoos, and even open wounds.

When creating a drawing of the human face, an artist will use a layout grid to determine the placement of the individual features. With a slight variation for either extremely wide faces or very narrow faces, the head is contained in an eight-unit-high by five-unit-wide rectangle. Each unit in the rectangle is equal to the width of one eye. From this basic unit each individual feature can be placed with great accuracy.

vampire facts

Using the Face Diagram

The facial features take up the lower half of the diagram. The area contains the eyes, nose, mouth and chin area, and the ears.

Working from the grid lines:

- Create the nose in the middle unit. It is one-unit-wide by two-units-long. The nose tapers from one-half-unit thick at the bridge point to one-unit-thick at the nostrils. The nostrils are about one-half-unit high.

- The eyes are one-unit-wide by one-half unit thick. They are separated by one full unit, which holds the nose. The bottom half of the eye unit contains the fullness of the lower eyelid.

- The pupils of the eye rest on the centerline of the eye unit. The pupils are each a half circle that disappears into the upper eyelid. The pupils are a total of two units apart from each other.

- The mouth is two-units-wide and placed directly under the pupil lines. It lies in the bottom half of the unit beneath the nose. The lower lip is fuller than the upper lip. The corners of the mouth curve to a point two-thirds of the way down into the unit.

- The chin lies in the last unit underneath the nose and fills just a little more than one-unit-wide.

- The jawline begins at the middle line of the lower half of the grid. The jawline slowly curves and angles down one unit before reaching across to the chin area.

- The ear begins at this middle line also reaching up into the forehead area of the face. The ear mass stops at the center of the brow ridge.

- The highest point of the cheekbone lies where the bottom line of the unit that contains the eye is crossed by the central line for the pupil.

Transferring physical alterations

As you work with patterns in this book, remember that you can easily use the physical alterations shown on one vampire for any new vampire you're creating. For example, you can use the open mouth that displays the blood fangs for *Three Days Dead*, the eyeglasses shown in *The Professor*, and the hat from *Leather* by simply tracing the elements onto your new layout.

Eyes

The eye area of the face is composed of lower-eyelid pads with wrinkles; lower-eyelid edge; the eyeball, which includes the iris and pupil; the upper-eyelid edge; the upper-eyelid pad and wrinkle; and the brow line.

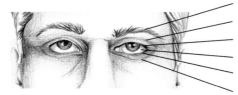

brow line
upper eye lid wrinkle
upper eye lid edge
eye ball
lower eye lid edge
lower eye lid wrinkle

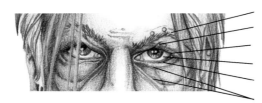

brow line
upper eye lid wrinkle
upper eye lid edge
eye ball
lower eye lid edge
lower eye lid wrinkle

The eye areas for both humans (above) and vampires (below).

Highlights and shadows

Simple line pattern for a young human male. Only the most basic, necessary lines are used in this pattern to establish the placement of the eyebrows, eyes, nose, mouth, and hairline.

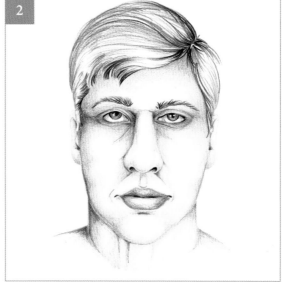

Major shadow and highlights. This colored pencil sketch shows the major shadow and highlight areas of the male face. The tip of the nose is the most forward-thrusting element. The forehead, just above the brow line, the top of the cheeks, and the top of the chin, all fall on the same basic plane in the middle height of the face. The eyes and eye-socket areas are the deepest—notice that in the drawing the area is carrying one half of the face's shadows.

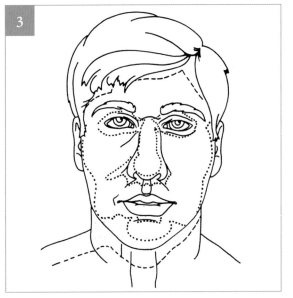

Deep shadow areas. Working from the pencil drawing, I have used a broken line to encircle the deep shadow areas of the eyes, along the sides of the nose, at the outer edges of the cheeks and jaw line, and beneath vshadow just as the jaw and chin cast a shadow onto the neck.

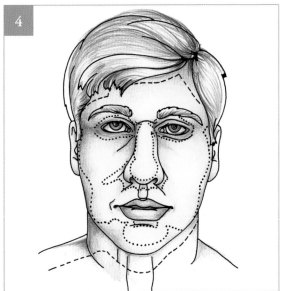

Edges of facial shadows. By overlaying the line pattern on the drawing, you can see how the broken line runs along the edges of the facial shadows.

vampire facts

Count von Count, the Muppet vampire from Sesame Street, is based on actual vampire myth regarding ways to deter vampires. One method is to throw seeds (usually mustard) outside a door. A second is to place fishing net outside a window. Vampire myth suggests they are compelled to count the seeds or the holes in the net, delaying them until the sun comes up.

Dundes, Alan. 1998. *The Vampire: A Case Book.* Madison, WI: University of Wisconsin Press.

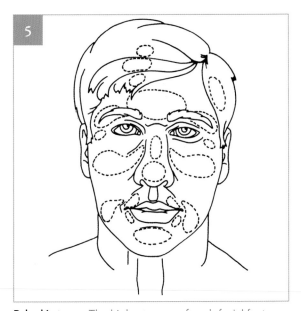

Pale skin tones. The highest areas of each facial feature will carry a highlight of pale skin tones. Where his eye shadows fall in the medium- to dark-brown range on a basic skin color of soft gold-orange, the highlights for this sample are worked in a light beige tone. This highlighting has been marked on the simple line pattern using a broken line where I have used that beige coloring.

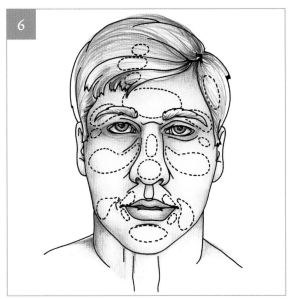

Brightest highlights. Overlaying the highlight pattern on the pencil drawing, you can see the brightest highlights fall on the forehead at the center of the brows, the center ridge of the nose and the top of the nose ball, the top of the chin, and where the sides of the mouth push against the lower cheek. Because the hair is as important as the facial structures, I have also noted the highlights in the forward falling bangs and along his left side.

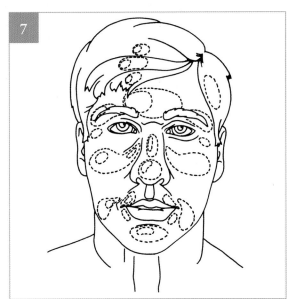

Graduated tones. A shadowed area will have several graded tones of the shading color: medium brown, dark brown, and black brown. Highlights also show gradations: golden orange, creamy orange, beige, and bright white. I have added the brightest highlights, the white highlights, to this pattern.

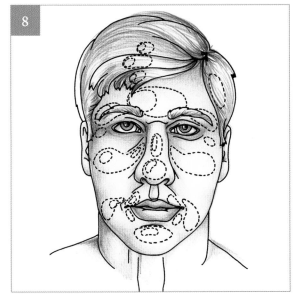

White highlights. Skin can have very white highlights no matter what skin tone your vampire has. The white areas are caused by direct sunlight hitting the highest points of the facial structures.

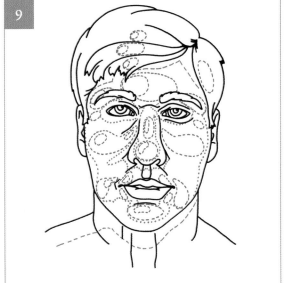

Completed pattern. The completed pattern shows the basic facial features in black, the shadow lines in blue, and the highlight areas in red.

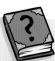

UNANSWERED VAMPIRE QUESTIONS If someone is killed by a vampire and becomes a vampire, do they get a funeral? Is there even a body to bury?

36

Drawing Facial Changes

There are several very simple changes to the basic human face that transform your portrait into a vampire—deeply set eyes, dark shadows around the eyes, boney brow ridges, and even hairstyles. Subtle changes in any or all of those areas easily transform your human face into vampire art.

OPPOSITE: With just a few simple changes to the features of the average human face, vampire artists can master their own creations.

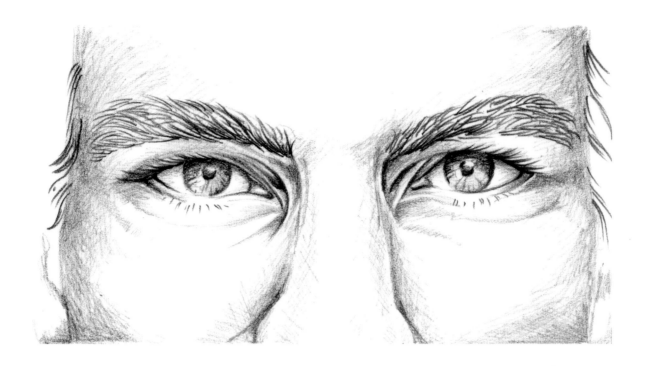

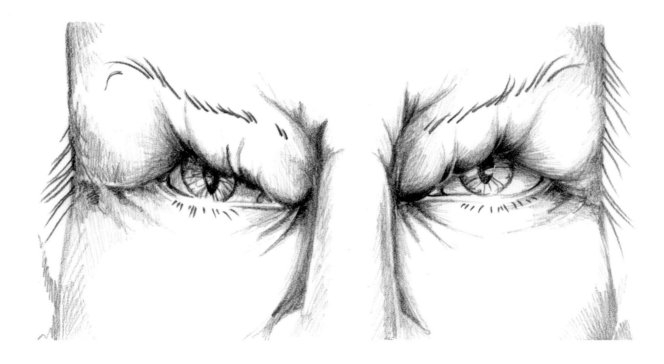

Proportions

A vampire artist needs to do no more than create extremely dark shadowed eyes to create the impression of death or disease. The eyes are already the deepest set points in the face. By pushing them, the surrounding eyelids, and the eye pads above the lids, and adding an area of dark tones below the lower lids, the face gains a sunken appearance.

This is the colored pencil work for the basic male face converted to a gray scale image. In this sample, the darkest points of shadow fall in the eye pupils, the nostrils, the slight opening in the mouth, and in the forward part of the hair.

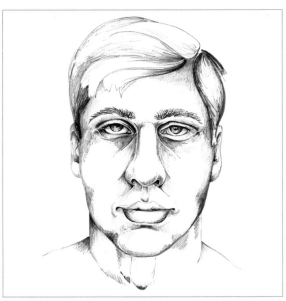

In this graphite pencil drawing of the same basic male face, the areas above and below the eye have been deepened to a harsher black tonal value. The shading technique is more coarse and exaggerated, creating a dramatic contrast between the white highlights and black shadows. Only a few mid-tone values were used. By forcing the tonal value into a stark contrast, the eyes and eye shadow areas become dominant.

vampire facts

Vampire hysteria and corpse mutilations to "kill" suspected vampires were so pervasive in Europe during the mid-eighteenth century that some rulers created laws to prevent the unearthing of bodies. In some areas, mass hysteria led to public executions of people believed to be vampires.

Dundes, Alan. 1998. *The Vampire: A Case Book*. Madison, WI: University of Wisconsin Press.

UNANSWERED VAMPIRE QUESTIONS How does one "rise from the grave?" How do you get out of a coffin under six feet of dirt or are all vampires buried in a shallow grave by previous arrangement?

Simple eye changes

Changing the line that creates the upper and lower eyelids affects the depth of the eyes, the brow ridge, and the cheek area below the eyes.

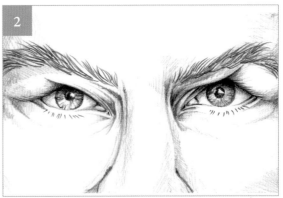

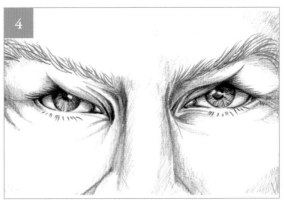

The average male eye falls below a softly curved brow line. The brow line for many men can appear almost straight or parallel to the pupils of the eyes. The strongest wrinkles appear at the inner corners of the eyes where the eye joins the bridge of the nose. The underside of the upper eyelid will be dark, with the inside edge of the lower eyelid bright or white. Notice the eyeball is shadowed along the top of the curve where it touches the upper eyelid.

The first eye change happens to the upper-eyelid pad and wrinkle. This line is cut into two lines with the line closest to the nose bridge angling upward and overlapping the second upper-eyelid pad and wrinkle. The brow line has a slightly tighter arch at the outer one-third point of the line. These slight changes cause the eyes to appear compressed at the inner eye corner.

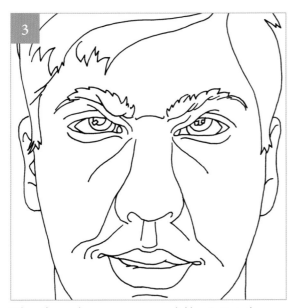

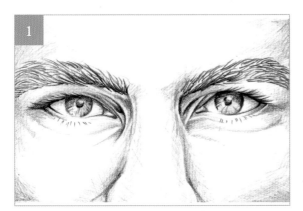

Emphasize these changes by extending the inner upper-eyelid wrinkle line and arching the brow further, compressing the eyes even more.

When the eyebrows or upper eyelid begin to arch, the skin at the bridge of the nose and along the upper cheek line becomes taut. This can cause a wrinkle line along the top of the cheek and extra wrinkles at the side of the nose bridge.

40

SIMPLE EYE CHANGES CHECKLIST

❑ Arched brows give the face an angry look.

❑ Tightening the brows at the nose bridge compresses the brow line with added wrinkles.

❑ Breaking the upper eyelid line into two segments adds an extra shadow area above the eye.

❑ Adding multiple wrinkles along the upper eyelid line shows the trademark of the modern vampire.

❑ Reducing the eyebrow hair emphasizes the new swollen wrinkles above the eye.

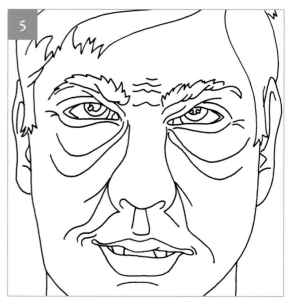

As the upper eyelid and brow line are pulled into a tighter arch, the wrinkles around the cheek, cheek edge of the nostrils, and in the low forehead area at the nose bridge become more pronounced.

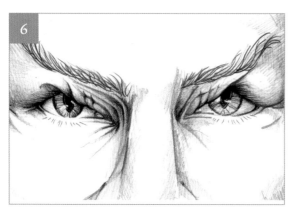

At the arch in the eyebrow, lift the outer one-third of the brow into an upward hook. The upper eyelid pad wrinkle has added folds because of the pull on the skin caused by the brow lifting. The more wrinkles you create along the main upper eyelid wrinkle, the darker this area will become with shadow work. The eye pupils have been changed from round to diamond shaped.

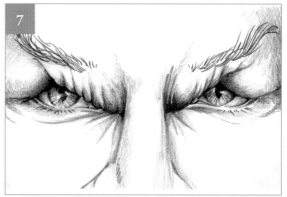

The eyebrow line now runs at a 30° line from the bridge of the nose. The upper eyelid wrinkle has a ripple effect because of the series of finely packed small wrinkle lines. Where the nose bridge meets the forehead, the bridge area has begun to thicken. The inner line of the upper eyelid pad now has an upturn at the end. This creates a double-V effect with both the brow line and the upper eyelid line pointing down toward the nose bridge.

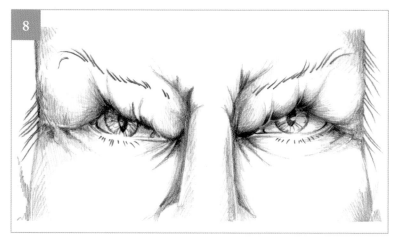

This last change shows the eyebrow ridge with little or no brow hair, with the entire brow line raised to a higher point in the forehead. The nose bridge is swollen, causing more wrinkles in the forehead area where the nose and forehead meet. The smaller wrinkles in the eyelid pad area have been worked into just a few large areas. The eyeball now carries heavier shading because of the thickened, swollen upper-eyelid pad.

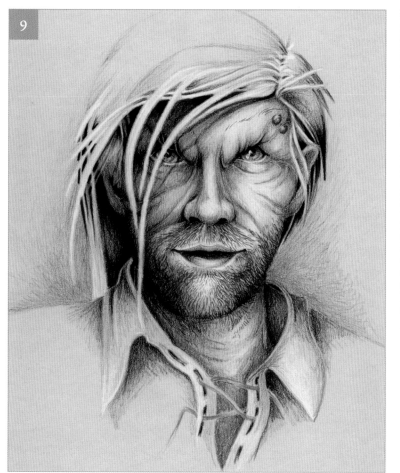

Grey Ghost uses the modern vampire physiology with an eyebrow line that lies high into the forehead area, little or no eyebrow hair, the thickened joint of the nose and forehead, and the heavily wrinkled upper eyelid pad. In this work, the only clue to his vampirism is found in the eye area of the portrait.

vampire facts

Prehistoric stone monuments called dolmens have been found over graves in northwest Europe. Anthropologists speculate they have been placed over graves to keep vampires from rising.

Greer, John Michael. *Monsters*. 2001. Woodbury, MN: Llewellyn Worldwide.

Hair changes

Hair, beards, and mustaches are elements of a portrait that can easily be changed to give more drama and mystery to your design. The hairstyle you choose can place your vampire into a particular era, historical setting, or cultural group.

Worked from the basic male face, this vampire has his hair pulled forward, covering a large portion of the left side of his face. This area of overflowing bangs will cast dark shadows on the left side that will dramatically darken this area. Because the bangs fall in strands, we are still able to see parts of the left eye. Because this is not an extreme version of the vampire, his hair styling on his left side still remains but the right side has become extra long and staggered into layers.

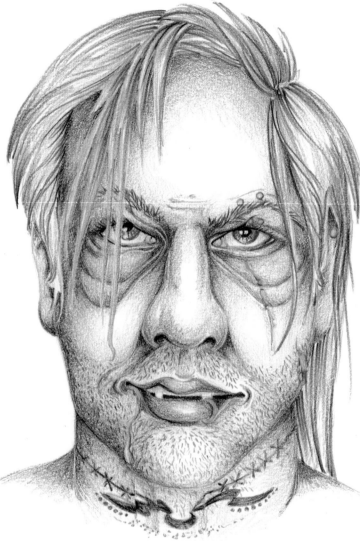

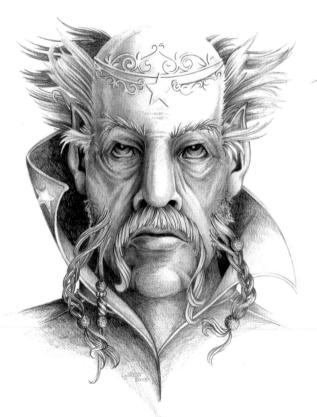

The top of *Risen King's* head is bald. The hair that begins around the temples flows up and out from the face. His hair extends in many directions, not one direction as if with the wind; it explodes into fine pointed strands. The mustache is highly adorned with braids, beads, and tight curls. Notice the arched eyebrow line, the double-lined upper eyelid wrinkle, and deep shadows surrounding the eyes.

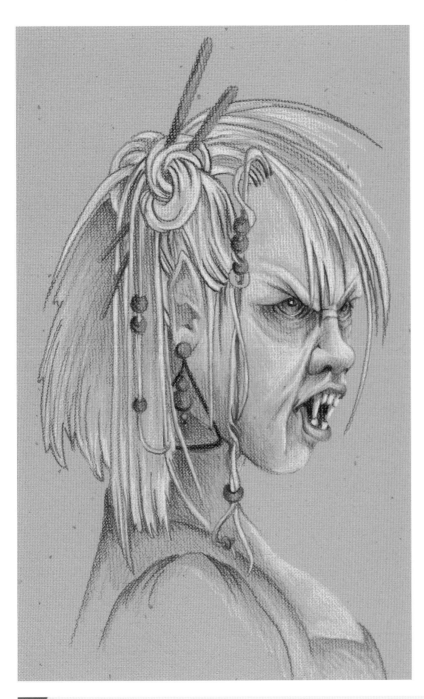

HAIR, BEARD, MUSTACHE CHECKLIST

❑ Overhanging bangs cast dark shadows onto the face.

❑ Staggered, uneven layers of hair imply a wild or unkempt effect.

❑ Hair that flows away from the face implies motion.

❑ Hair that flows upward into staggered points implies explosion.

❑ Harsh pointed strands of hair near the mouth emphasize the blood fangs.

Knot's hair falls down in deeply pointed spikes. Although she sports a neatly knotted hair bun the remaining hair uses staggered, uneven layers. Her forward hanging bangs will also shadow all but a thin strip of her face.

vampire facts

A rare enzyme disorder called porphyria (also called the vampire or Dracula disease) causes vampire-like symptoms, such as an extreme sensitivity to sunlight and sometimes hairiness. In extreme cases, teeth might be stained reddish brown, and eventually the patient may go mad. Notable sufferers are believed to have included King George III, Mary, Queen of Scots, and…Vlad the Impaler.

Greer, John Michael. *Monsters.* 2001.
Woodbury, MN: Llewellyn Worldwide.

Blood fangs

The classic position for blood fangs is at the side of the upper row of teeth at the canine tooth placement. Because the upper teeth extend forward and overlap the lower teeth there is plenty of room in the human mouth for blood fangs and for the lips of the mouth to close comfortably. Vampires can have a range of blood fang positions including a full upper row of fangs, an upper row of fangs with lower row canine fangs, and a mouth full of twisted, out of alignment fangs of varying lengths.

Raven (right) has both upper and lower canine teeth blood fangs. Because of the feeding frenzy open mouth, the lines along her cheeks from the nose to the lower edge of the mouth are exaggerated.

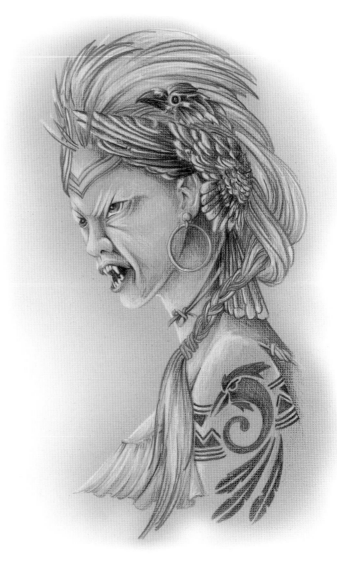

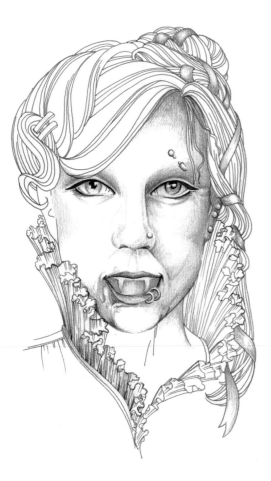

Pretty in Pink (left) shows the classic canine teeth blood fangs. Notice the lack of distortion in her upper lip: there is more than enough room in the mouth for these extensions.

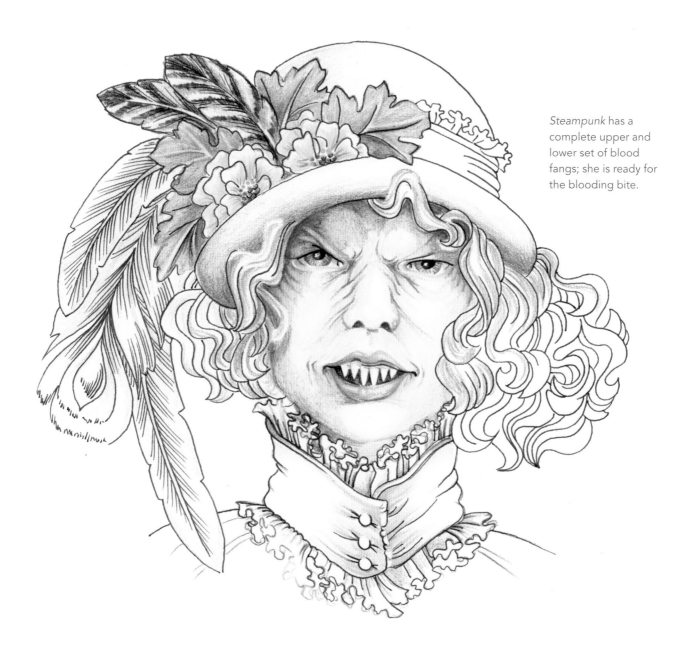

Steampunk has a complete upper and lower set of blood fangs; she is ready for the blooding bite.

BLOOD FANG CHECKLIST

❏ Upper canine teeth are the classic blood fang position.

❏ The lower row of teeth may have smaller blood fangs in the canine placement.

❏ All of the teeth for both upper and lower can be points, but the blood fang itself will be the largest, longest tooth.

❏ Some vampires teeth are twisted and out of alignment.

Scars and open wounds

Vampires are neither alive nor dead and they do not seem to decompose. There are two ways to show this undead stage—open wounds or mutilations to the face and skin coloring. We will look at open wounds through this section. Wounds often distort the skin area surrounding the cut with extra lines of wrinkles and even ridges of thickened skin. The insides of a wound may be red, orange-pink, or even greenish in cast. The outer edge of a wound may show a fine white line.

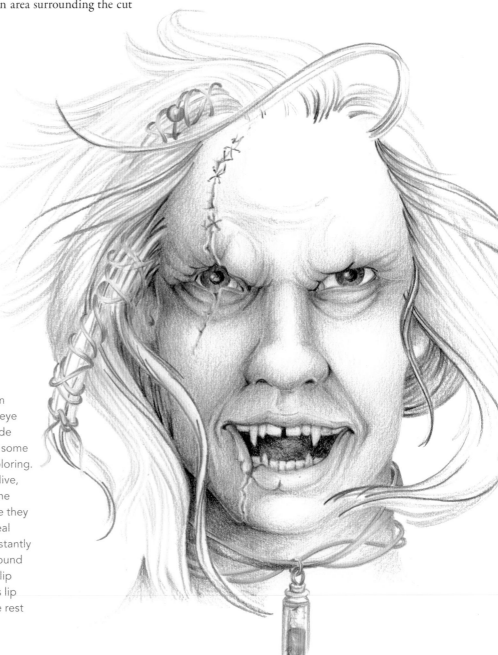

A long open wound runs from the hairline to below the left eye of *Three Days Dead*. The inside cut area of the wound shows some bright red and pink-peach coloring. Because the vampire is not alive, wounds cannot go through the healing process. Yet, because they are not dead, wounds may seal enough that they do not constantly drip with blood. A second wound on the lower lip disports the lip line, pulling the corner of this lip into a lower position than the rest of the lip.

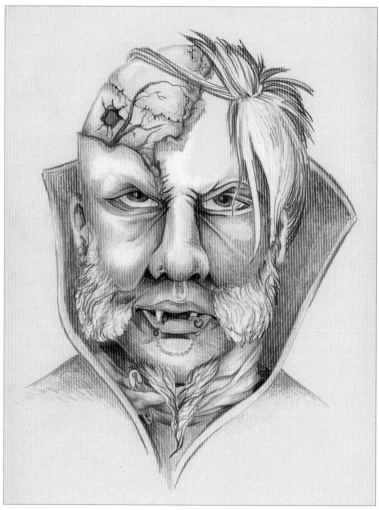

OPEN WOUNDS CHECKLIST

❏ Unhealed, open wounds helps to strengthen the undead nature of vampires.

❏ Many wounds are self-stitched, which creates a ragged uneven layer of thread over the wound.

❏ Wounds distort the skin and muscle areas surrounding them by pulling against the skin.

❏ Red, orange-pink, and even green tones may show in the center cut line of the wound.

❏ The inner skin edge of the wound is often white in coloring with darker tones of the vampires skin coloring along the outer reaches of the scar.

❏ The wounds from the original blooding may appear along the neckline.

The poor soul that tried to stop this vampire with a rifle only succeeded in making him very angry. *Bullet Hole* shows the bullet wound, a broken skull, and vivid torn flesh.

vampire facts

Documented medical disorders that people accused of being a vampire may have suffered from include *haematodipsia*, which is a sexual thirst for blood, and *hemeralopia* or day blindness. Anemia (*bloodlessness*) was often mistaken for a symptom of a vampire attack.

Melton, J. Gordon. 1999. *The Vampire Book: The Encyclopedia of the Dead.*
Farmington Hills, MI: Visible Ink Press.

UNANSWERED VAMPIRE QUESTIONS If a vampire catches a witch or warlock as their prey and turns them into a vampire, does the new vampire keep or lose their magical powers because he or she is now a vampire?

Drawing a Vampire's Garments

What your vampire wears gives important information to what type of vampire they are and to the era in which they were turned or lived. In the case of clothing, hats, hoods, and adornments, a few minor details can turn your vampire art into something spectacular. Minor details can indeed tell great stories.

OPPOSITE: *Leather* uses an extended hat brim to place his vampire eyes in darkness. Notice that the curve of the facial shadow matches the curve of the hat brim. He adds a layer of spiked hair strands, escaping from the hat brim area, to add an additional layer between you and his eyes. *Leather's* hat would have made him at home in the 1800s, or even the 1970s, when similar hats found their way into pop culture fashion. The leather aspects of his attire could easily find him a place in various subcultures from any period.

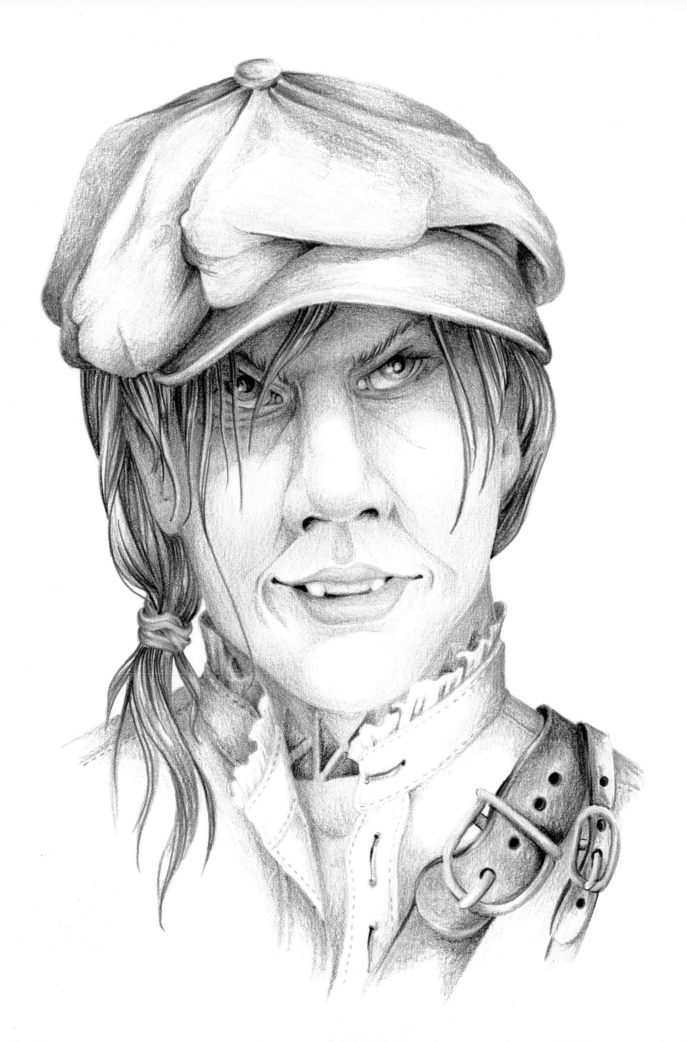

Hats and hoods

All vampires seem preoccupied with their need to hide their true nature. Lurking in the shadows of dark alleyways, avoiding bright streetlights, and keeping their heads tilted in a downward position help them to escape your direct, clear view. Hats, shawls, hoods, and collars are a way that an artist can show the vampire's need to hide from public attention.

Straight out of the 1700s, *The Good Reverend* still wears his monk's cloak and hood. If you encountered him in that dark alleyway or in the graveyard, you would know instantly he is an ancient vampire.

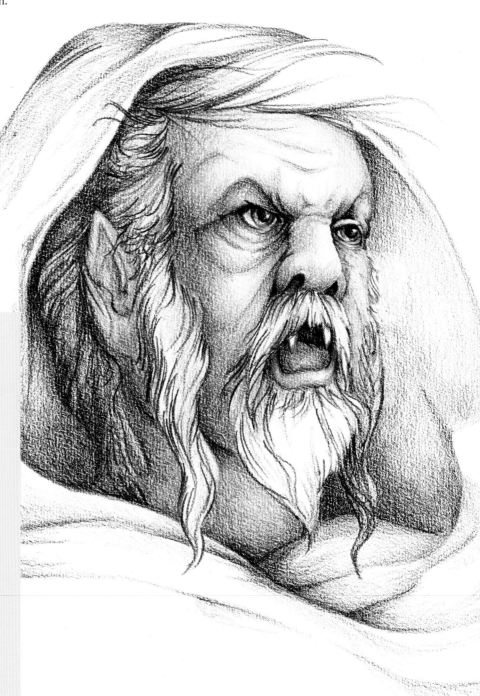

vampire facts

Vampires in China were called a ch'iang shih (corpse-hopper) and had red eyes and crooked claws. They were said to have a strong sexual drive that led them to attack women. As they grew stronger, the ch'iang shih gained the ability to fly, grew long white hair, and could transform into a wolf.

Bartlett, Wayne and Flavia Idriceanu. 2006. *Legends of Blood: The Vampire in History and Myth*. Westport, CT: Praeger Publishers.

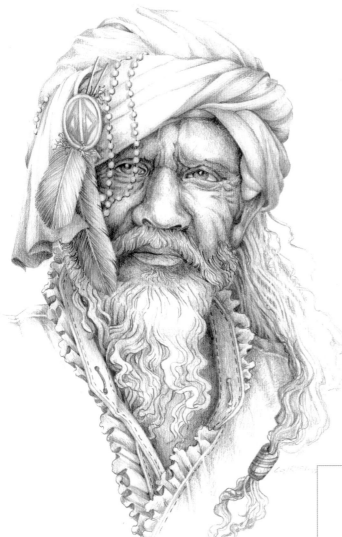

vampire facts

Countess Elizabeth Bathory (1560-1614) was one of the most famous *true* vampires in history. Bathory was accused of tremendous atrocities, including biting the flesh off girls while torturing them and bathing in their blood to retain her youthful beauty.

Melton, J. Gordon. 1999.
*The Vampire Book:
The Encyclopedia of the Dead.*
Farmington Hills, MI:
Visible Ink Press.

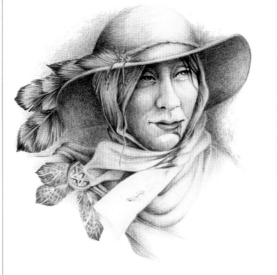

This *Street Merchant* (above) has taken on a disguise that allows him full access to a range of victims. The addition of beads and a pendant to his wrapped headscarf, the feathers, and the heavily ruffled collar pull your attention away from his face. He wants you to look at what he wears, not at who—or what— he is.

The Matron is an extreme example of using clothing and garb to hide the nature of a vampire. Her hat has a wide brim that casts a deep, low shadow on her face. Her hair is hidden under her head wrapped shawl. That same shawl covers her throat and her vampire bite wounds. She is so well hidden that the only clue that she is a vampire is the telling stain of blood at the corner of her mouth.

UNANSWERED VAMPIRE QUESTIONS If you have a flock of bats, is a group of vampires called a flock…covenant (witches)…clutch (dragons)…or just a horde?

52

HAT AND HOODS CHECKLIST

❏ Hats with large brim areas cast shadows onto the upper portion of the face.

❏ Long strands of bang hair also add a layer of shadow over the eye area.

❏ Adornments, such as beads and braids, can be added to overhanging bangs to draw your attention away from the vampire's eyes.

❏ Shawls, ribbon necklaces, and high collars can be used to cover the bloody wounds on the neck.

❏ Reading glasses and sunglasses hide the vampire's eyes from clear view.

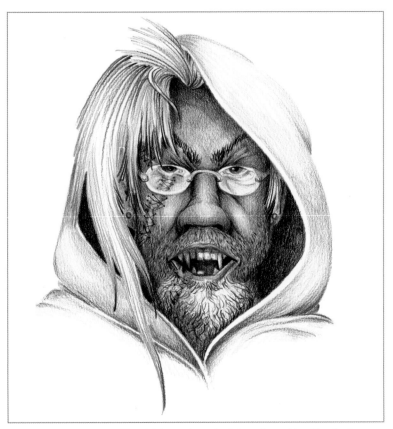

The thick woolen cloak hood used by *The Professor* (above) casts a harsh and dramatic shadow along his forehead area. He has added a very thick mane of spiked hair that escapes beyond the hood and moves into the foreground position. Even eyeglasses can be used to disguise the true nature of a vampire.

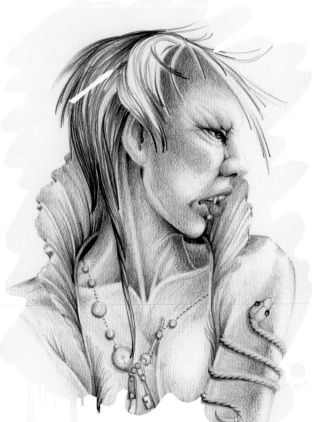

An ancient gold-coiled snake arm bracelet adorns *Attitude's* arm, yet a modern steampunk necklace accents her throat. This vamp is strong and confident in her desire to mix and match era costume jewelry.

Adornments

Where the ancient vampire may have little or no extra adornments, today's vampires can sport tattoos, piercing, beaded jewelry, heavy make-up, and highly styled hairdos. Adornments are often used to divert your attention.

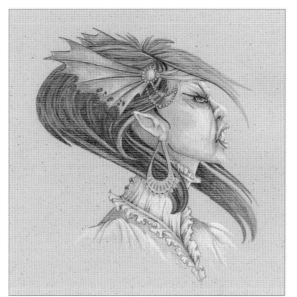

Worked in an illustrative art style, *Bat Wings* heavily relies upon jewelry, lace, and blouse ruffles to bring bright colors to the work. Large gold bat wings are used as hair barrettes and accent the extra large teardrop earrings. Pink satin trims the bodice line of the blouse ruffle to carry the lip gloss color into her garb.

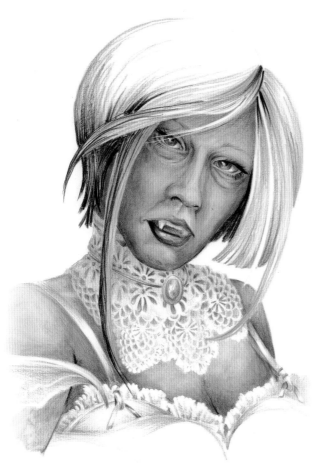

The white crocheted collar and heavily jeweled throat brooch imply the mid- to late-1800s for *Lonely Nights*. The pink ruffled bra may move her forward into the 1970s but the V-neck spaghetti strap tank top shows her to be contemporary. Perhaps with each new era of history *Lonely Nights* has seen, she has simply put on a new layering of cloth to match that period of time.

ADORNMENTS CHECKLIST

❑ Beads, feathers, and pendants can be added to braided strands of hair.

❑ Clothing for either male or female vampires may have ruffles or lace added.

❑ Tattoos can be used to place a vampire into a specific era or to represent something from his former life, such as a military tattoo or a neo-tribal tattoo.

❑ Piercing and earrings can be added along with any type of jewelry necklaces.

❑ Tied ribbons or tied clusters of leather strips may be wrapped around the neck.

❑ Headbands, beaded strands, and hair clips can adorn the upper face.

Expressing a Vampire's Nature When Drawing

Because vampires prey on both our bodies and our emotions, transferring our state of high anxiety directly to the vampire portrait through anger and potential violence is a natural part of vampire art. Their cunning hunting tactics leave every believer in a constant state of fear when walking the streets during the night hours. Superhuman strength and agility remind us of our own human vulnerabilities.

OPPOSITE: *Anger* uses a stiff straight back line to emphasize her scowl. The extra dark shadows surrounding her eyes draw attention to the three lines that join at the inner corner of her eye area—the brow line, the inner upper eyelid fold, and the outer upper eyelid fold. The deep cheek line that intersects the inner eye corner accents the other three lines mentioned. Together, these four harsh lines, reinforced with the dark eye shadows, create the angry expression of this portrait.

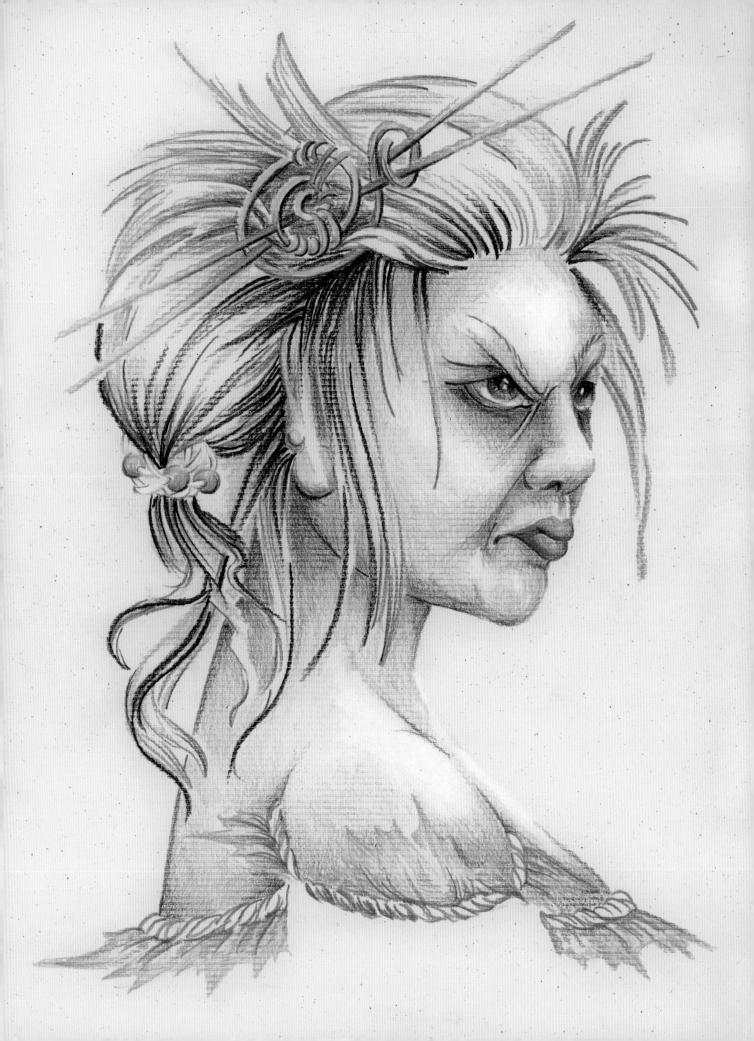

Emotions

There is a lot of speculation as to whether or not vampires feel emotions. Some contend vampires can't feel emotions per se, but do feel something akin to memories of emotions from their previous lives. Others believe vampires definitely feel emotions, and in fact, their emotions are more intense than human emotions. It is the vampire artist's responsibility to depict how their vampires deal with emotions. Some emotions, anger for instance, are relatively easy to convey. Other emotions can require careful consideration and work for proper expression. Vampire artists can do much with various types of facial lines.

Shadows (above) shows his vampirism only through his gray-yellow skin coloring. No other physical feature reveals his true nature. Yet, without a doubt his true vamp nature is revealed in his secretive smirk. Hiding the eyes under the shadow cast by his hair, pulling an accent of reddish tones into the hair shadowed side of his face, and a slight twist to the mouth creates the half smile effect.

Wind Swept uses a limited color palette. Deep red purple, deep indigo blue, and white create the skin coloration. In contrast, bright reds and oranges are used to emphasize the mouth, lower eye wrinkles, and the inside edge of the lower eyelid. Bringing this bright red coloring directly into the eye areas of *Wind Swept* gives the angry expression strength.

EMOTIONS CHECKLIST

❏ Create anger by lowering the inner eyebrow and upper eyelid corner. The deeper the angular lines become, the more violent or rage-filled the vampire becomes.

❏ Dark set eyes and dark shadows under the eye bring your attention to the eye area and therefore to the angular lines that show the vampire's emotional state.

❏ A slightly lifted eyebrow and small twist to one mouth corner can create a smirk or half-smile for your portrait.

❏ Try a limited skin color palette for your vampire with bright colored accents to re-enforce the emotional lines of the face— red on the inner lower eyelid and dark blue to the eye shadows.

Thinly Veiled tries to hide her recent vampirism neck wound with a lightly colored translucent veil. The bloodstain on her neck is strengthened by the use of its complimentary color green throughout the clothing.

TELL-TALE BLOOD CHECKLIST

❏ Blood drips around the mouth can easily change any portrait into a vampire's portrait.

❏ Consider adding blood around the mouth areas by adding streaks of blood to a vampires beard or mustache.

❏ Add a smear or fine streaks of blood along the lower cheek, chin, and jawline.

❏ Neck wounds for the recently risen vampire can be either simple open wound holes or can be draining blood down along the collarbone and breast of the vamp.

❏ Neck wounds can be hidden from view with a scarf, ribbon necklace, or collar, yet these areas may show spots or stains of red from the blooding wound below them.

Tell-tale blood

As noted several times throughout this exploration of the vampire, many modern vampires show little or no physical attributes to clue you to their true nature. A modern vampire who is not in the feeding frenzy can look totally human. However, a small hint of bloodstain left around the corners of the mouth, at the neckline, or on the clothing can quickly turn that perfectly normal human look into a vampire.

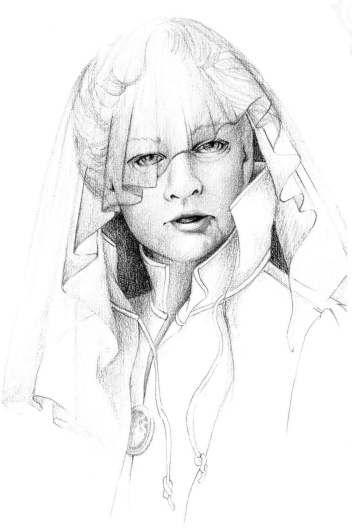

A small hint of blood at the corners of the mouth and along the right-side chin of *Black Bride* imply a sad ending for her groom on the couple's wedding night. Although only a small amount of blood is used in *Black Bride*, the pale yellow and soft blue coloring of the overall portrait tend to make the red stronger.

58

Drawing a Vampire From a Photograph

Is there a relative, classmate, or adult in your life who you feel is literally sucking the life out of you? Take that frustration and channel it into some great art.

Creating vampire art based on a photograph of a friend, relative, teacher, or other person in your life can be a fun project. Whether you are making vampire art or a traditional piece, working from photographs offers some challenges and resolves many others. Up to this point, we have explored many ways in which vampirism can be expressed in our art. Before we work on skin coloring, let's work through a sample photograph to create several versions of the vampire.

The conversion process has nine steps, beginning with converting the photo to gray scale using computer software. After that, the vampire artist will need to convert the photo to a line drawing and establish areas for highlights and shadows. Follow along and give your project your best shot.

OPPOSITE INSET: A classic high school yearbook photograph for demonstration purposes, scanned at 200 percent of its original size and 300 dots per inch density.

OPPOSITE: A few open self-stitched wounds along the right side of his face adds the undead, semi-decomposing effect.

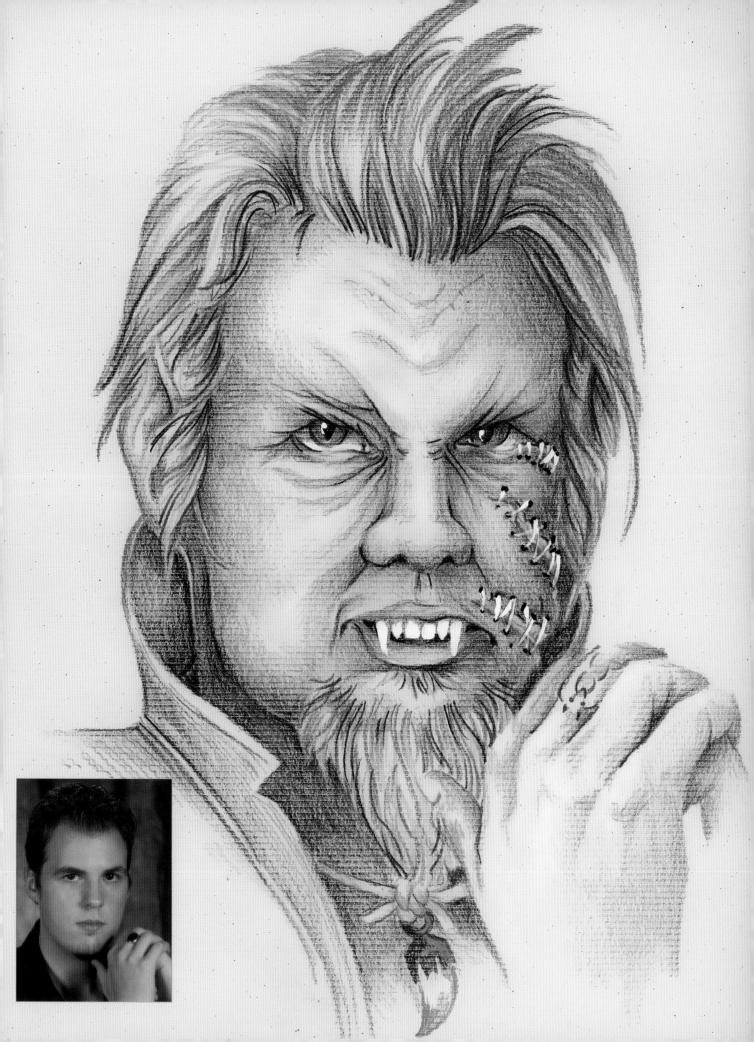

Photo Conversion Process

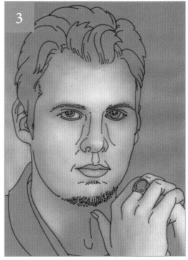

Using a classic high school yearbook photograph for demonstration purposes, I have scanned the photo into my computer at 200 percent of its original size and at a 300 dots per inch density. Those image specifications create a large computer image.

I have converted the photograph to gray scale using one of my graphics programs. Converting the photo to gray scale removes all of the color information from the photo allowing me to work easily with the shadows and highlights of the face. After gray scaling I printed a copy of the photo at 8" wide and 10" high to create as large an image as my printer will make.

Next, cut a piece of tracing vellum or tracing paper the same size as the printed photograph. Tape the tracing paper to the top edge of the photo so that it does not move during the sketching process. Trace along the outer lines of the main features of your subject with a 2B or 4B graphite pencil. Include the pupils, irises, and eyelids, brow line, the sides and edges of the nose, the mouth, chin line, and any hair lines. Add any deep wrinkle lines in the face to this basic pattern. This will become the tracing pattern for the color artwork.

Lay a second sheet of tracing paper over the first and tape it into position. You will be able to see both the photo and the basic tracing pattern through the new sheet of tracing paper. With your pencil, mark in dashed lines along the edges of the darkest facial shadows. Use a dotted line to denote the edges of the highlights. You will refer back to this shadow and highlight pattern during the skin coloring stage of your art.

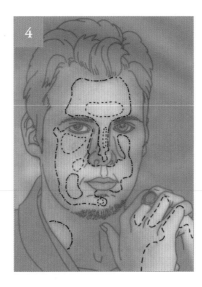

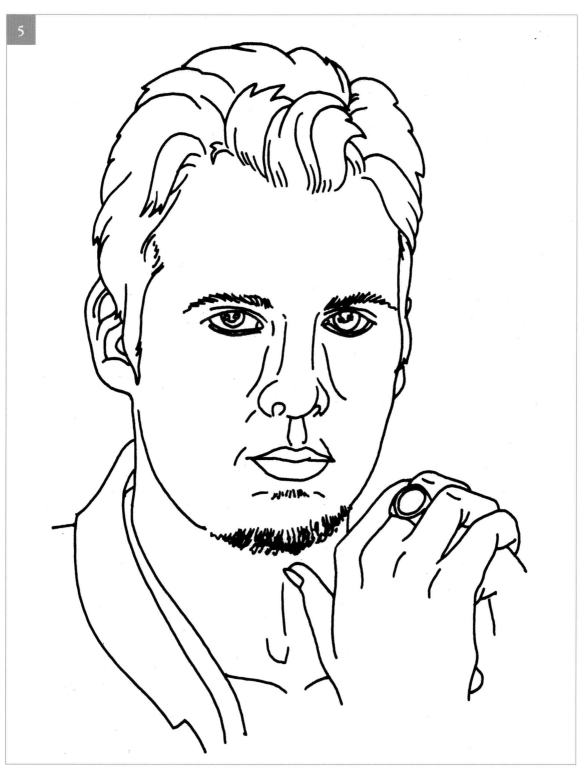

The finished tracing pattern uses as few lines as possible to show the boundaries of each facial feature.

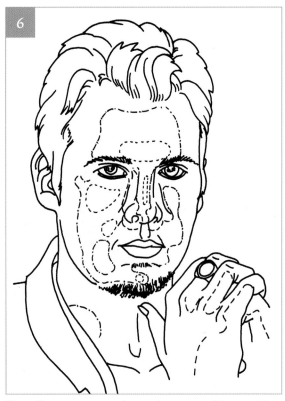

The reference pattern shows where you will be working the shadows and highlights to the face.

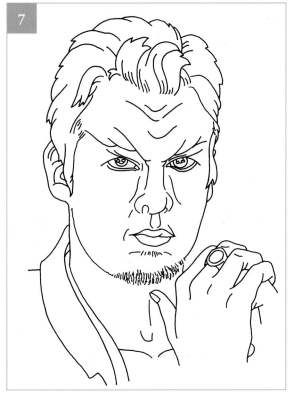

By laying a new sheet of tracing paper over my basic face pattern I can alter the pattern to take on vampire features. The first change is to create the brow line, furrowed forehead, and upper-eyelid pad area of my pattern. I have compressed the inner corners of the eye downward, lower along the nose bridge. The brow hairs have been completely eliminated. He now has the classic vampire eye features and an angry emotional expression.

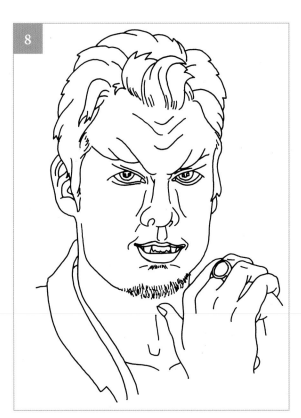

Opening the mouth slightly by thinning the upper lip and dropping the lower lip toward the chin gives me room to include the teeth, especially the blood fangs. Lifting the extreme ends of the mouth places the mouth into a sneer.

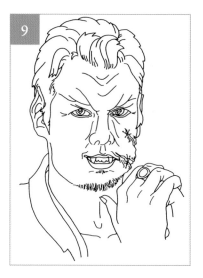

9

Adding an open wound or unhealed scar with a few hand done stitches allows vampire artists to distort portions of the face. These wounds pull the surrounding skin into the area of the cut. A wound near an eye will drop the lower eyelid of that eye out of alignment with the opposite eye's lower lid. If the cut falls near the mouth, the nearest corner of the mouth becomes drawn tightly toward the wound area.

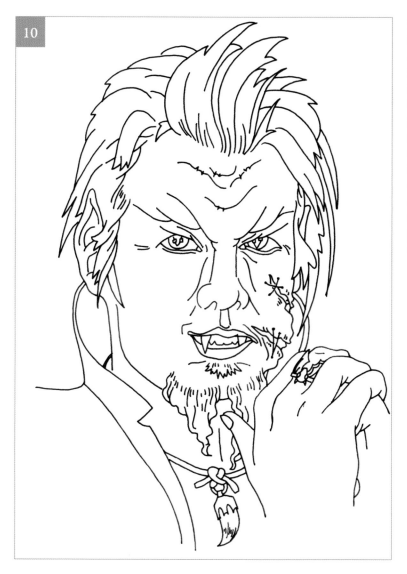

10

Finally it is time to adjust the hairstyle and clothing to place this vampire into a period. The use of the up-turned collar and the leather bound claw necklace makes him into an ancient vampire, sometime between the 1700 to 1800's. The spiked hair strands were worked directly from the photo's original hairstyle; they have simple been extended and staggered into differing lengths. With a few changes this high school yearbook photo has transformed into an eighteenth-century vampire.

UNANSWERED VAMPIRE QUESTIONS Where did all of the abandoned church catacombs that house vampires come from? How does a vampire move his coffin into the basement of a castle?

Creating a Vampire's Skin Coloring in Your Drawings

Skin coloring is probably the most important feature of any vampire artist's work. As noted in the research, vampires are extremely non-prejudicial in regard to their victims. So vampires and victims are found in every racial skin coloring known to humans—commonly called white, black, red, yellow and brown. A vampire may retain their living skin color or take on a coloring based on how they became vampirized, their current feeding state, or on their rate of semi-decomposition. As a result, add pale greenish blue, blue-gray, pale yellow, and mottled red-purple to the possible skin color list. In this chapter we will explore Vampires that retain their human skin coloring, focusing on both the pale yellow-peach skin and the rich red-brown dark skin. To see ideas for other Vampire skin colors please refer to Chapter 11.

OPPOSITE: *Lonely Nights* is an excellent example of multi-colored skin tones.

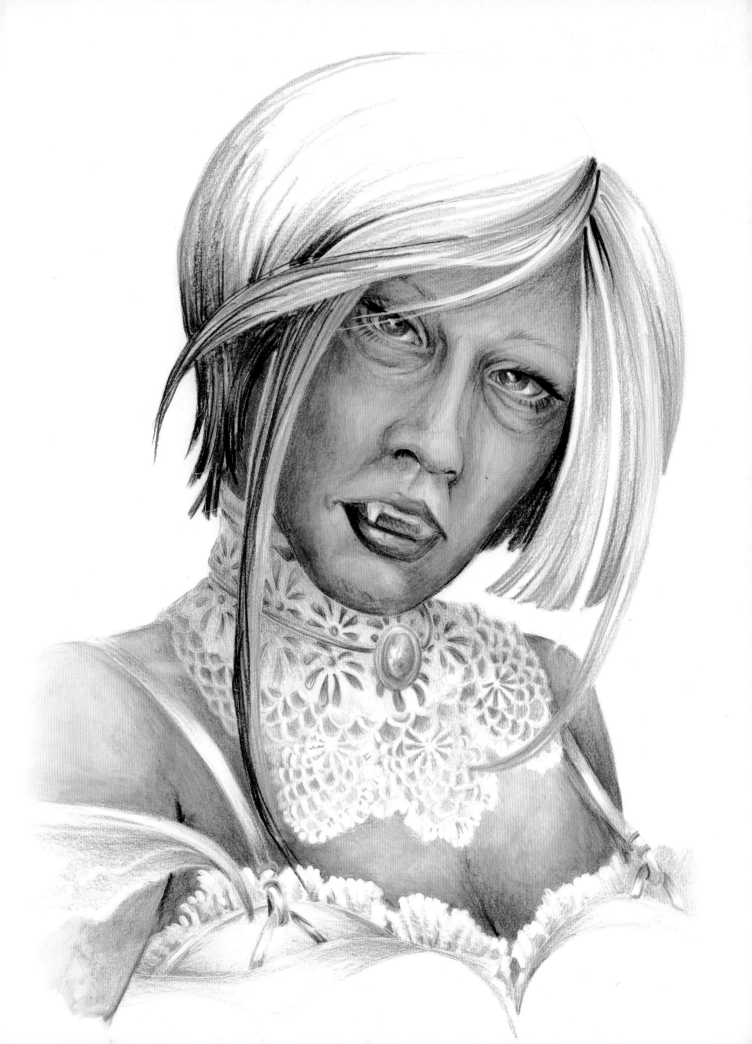

Pale Skin Tones

With all human skin coloring falling in the orange hue range, pale human skin toned vampires begin with a base coat of pale to medium yellow. To this yellow hue, white can be added to create the bright highlight areas where the facial skin is tight or thin as across the bridge of the nose, top of the chin, and across the brow ridgeline. Soft yellow-orange shading can be added for the medium hues as sienna brown, golden ochre, and goldenrod yellow in areas that lie high in the facial planes as the tops of the cheeks, center of the chin, and along the sides of the nose.

For darker shadows, go to the golden brown and orange browns as found in copper brown or burnt sienna. These two color pencils will add the shadows the fall along the inside eyelid areas, the wrinkles around the mouth, under the nose, and along the outer sides of the face. French gray and sand yellow act as blending tones with deep orange and Venetian red as the skin blush colors.

In the color image on page 67, the portrait we will be exploring through the stages of color work shows the same shadow, highlight, and wrinkle area in her final coloration.

So that you can see where the colors are being applied to the pattern, I have outlined the pattern with a 2B pencil (Figure A, page 67). This is done only so that you can clearly see the process. The right side pattern uses only the original gentle tracing pencil lines (Figure B, page 67).

For the step-by-step coloring process shown on pages 67 to 72, below both traced patterns I have drawn two straight lines to create an area where I can note each color used and the order in which they were applied.

The first light layers of color are used to establish where the darkest facial shadows will fall. I prefer to do these layers

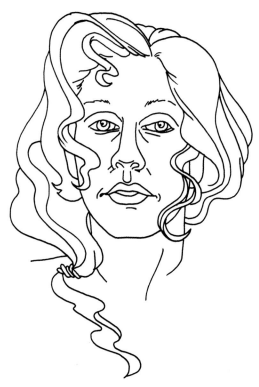

This Basic Female Face pattern will be used as the bases for creating a pale yellow-beige skin color. The procedures for creating the shadows, highlights, and wrinkle lines is the same for any skin color, only the actual colors used changes.

using a medium skin tone. Using golden sienna, I have shaded lightly along the sides of her face with the left side shading wider because of the overhanging hair.

When working in any color media—paints, pencils, pastels—use as few tracing lines as possible in the first stage of the work. Since artist-quality colored pencils are transparent, any pencil or tracing lines you apply will show through the final work. I rubbed the back of my printed pattern with a layer of 2B soft pencil.

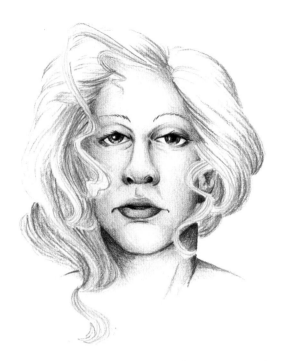

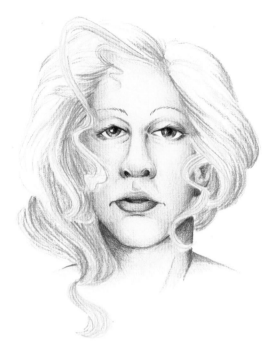

FIGURE A: The gray scale image of the Basic Female Face drawing shows where the shadow, highlight, and wrinkle areas of the face fall.

FIGURE B: In this color image, the portrait that we will be exploring through the different stages of color work show the same shadow, highlight, and wrinkle area in her final coloration.

I traced over Figure A (above) with a pencil using a darker line so readers can see the outline of the pattern as the stages develop. (I did not retrace Figure B because it would be the same as tracing Figure A.)

I have chosen four shades of yellow—primrose, sand, golden rod, and golden sienna; three shades of orange—light peach, chrome orange, and venetian red; two shades of gray—50% French gray, and 80% French gray; one color for her eyes—spruce green; and carbon black. This color selection will keep her skin pale in value and in the creamy orange-creamy beige range.

Several layers of venetian red have been added to my shaded areas where I worked the golden sienna. A few extra light layers are added to the left hair shade side of the face. The venetian red layer is worked closer to the edge or side of the face than the golden sienna.

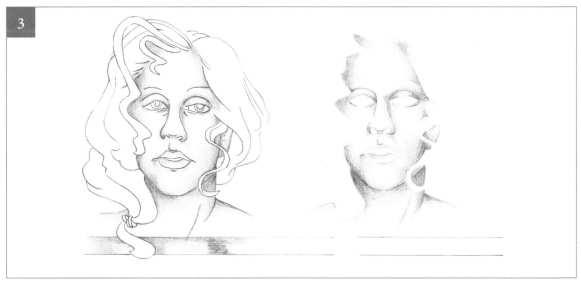

Primrose yellow is added next. This new color reaches even further into the face. At this point, three layers of shading have been added, with the darkest tone at the side of the face; the medium tone worked over the dark tone and reaching beyond it toward the center of the face; and a pale third shading color going even farther.

The areas that have no coloring are the top center forehead, top center cheeks, the nose ridge and the tip of the nose, and the top ball of the chin. In a portrait, each area of shading is slowly developed, beginning with mid-tones then working into the darker values.

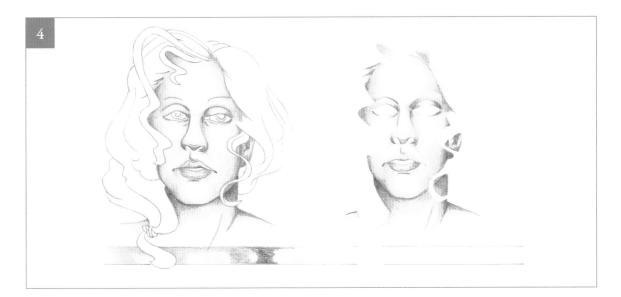

4

I added 90% French gray over the copper brown. The French gray is worked over the copper brown-golden sienna shading to even further darken the sides of the face, top of the neck, and the corner eye wrinkles. When the gray work has been completed, I have obvious areas of four different skin shadow

colors, with a harsh effect. To blend those colors into one graduated grouping, I have applied several light coats of light peach to the entire face. The light peach tones out the harsh red- and gray-oranges, bringing the colors back to a medium-tonal value.

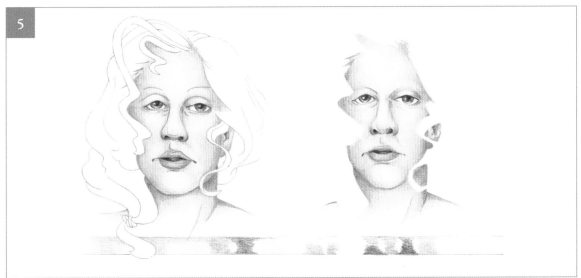

5

Colored pencil art is developed in multiple layers of color and then blended with a pale tone to unite those colors. In this image, I have repeated all of my early shading layers using the golden sienna, copper brown, primrose yellow, and 90% French gray. This second series of shading steps intensifies the coloring. Several layers of light peach were again used to unite and blend the repeated layers of shading tones. To further blend the skin, several layers of sand were added. To create the eyes, I worked 50% French gray over the whites of the eye just below the upper eyelid, extending the shading to both corners of the eye.

The upper eyelid shades the eyeball area. I worked several layers of spruce green into the pupil and then shaded where the pupil touches the upper eyelid with 50% French gray. A fine line of 90% French gray has been added along to the upper eyelid and at the outer corner of the lower eyelid line. The insides of the nostrils and inside of the open mouth also have 50% French gray worked throughout the entire area and then layers of 90% French gray worked for the darker shading in those areas. Layers of golden sienna alternated with copper brown and venetian red give the lips some color.

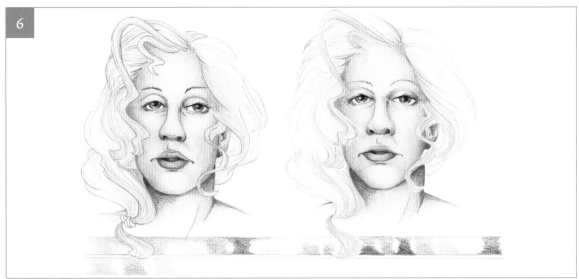

Using 90% French gray, I have added fine line eyebrows and eye lashes. Brows are created using many fine thin lines, not one harsh solid line. Eyelashes grow from the outer edge of the inside eyelid—there should be a thin line of eye skin coloring between the eyeball and the lower eyelashes. Black has been added to the top half of the eye pupils, the corners of the open mouth, and at the outer edges of the nostrils. One or two very light layers of chrome orange are worked over the sides of the face covering the golden sienna through 90% French gray shading. A light layer of chrome orange was added to the upper eyelid near the nose bridge. For my final blending in this step, I worked several layers of sand over all of the skin area, including the lips. When working any portrait, the color of the hair and clothing affects the color appearance of the face. I worked several layers of primrose yellow over all of the hair area and then accented some strands of hair using a little of each of the skin shading tones—golden sienna, venetian red, copper brown, and sand.

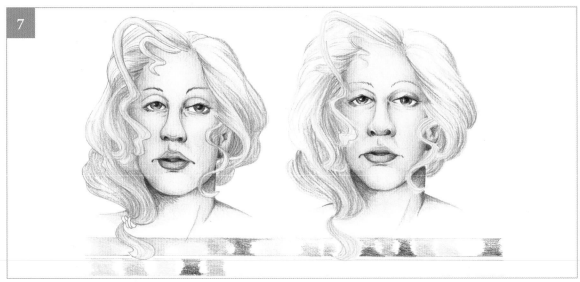

Fifty percent French gray becomes the shading color for the hair and is worked over all of the hair color layers in each shadow area. Added layers of golden sienna and golden rod develop the most intense hair color. Several light coats of titanium white are finally worked into the facial highlights in the top of the cheeks, ridge of the nose, top of the chin, and in the forehead between the eyebrows. Black has been reworked in the pupils and a few fine black eye lash lines added. The outer corners of the mouth have added black.

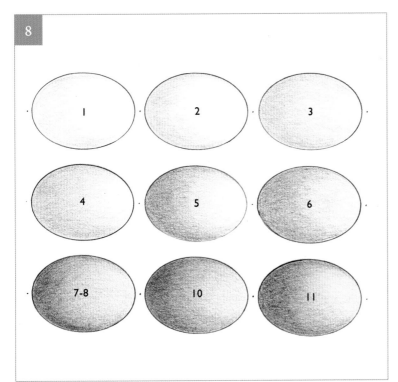

The chart at left shows the progression of colors that create the skin tone through each step of the instructions. Step 9 has been left out as that step worked with the eyes and eye brows.
1. golden sienna—shading tone.
2. venetian red—shading tone.
3. primrose yellow—shading tone. 4. repeat 1 through 3.
5. copper brown—shading tone.
6. 90% french gray—shading tone.
7. light peach—blending tone.
8. sand—blending tone. 9. eye color work—not shown on this chart 10. repeat steps 1 through 7.
11. chrome orange—blush titanium white—highlights.

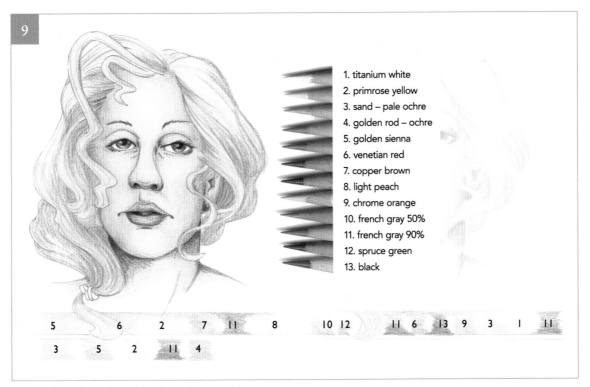

1. titanium white
2. primrose yellow
3. sand – pale ochre
4. golden rod – ochre
5. golden sienna
6. venetian red
7. copper brown
8. light peach
9. chrome orange
10. french gray 50%
11. french gray 90%
12. spruce green
13. black

Here is the color palette for this Basic Female Face.

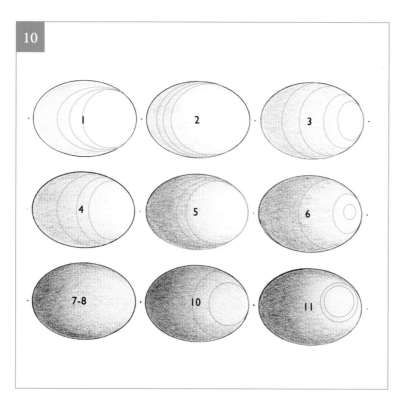

The chart at left is the same progression of colors as the color palette for the Basic Female Face, with a medium gray circle denoting the layers of each color worked in each step.

Creating Dark Skin

Dark human skins, often called brown or black skin, are also worked in the orange hues. The base color of copper brown or golden rod are several tonal values deeper than that of the pale human skin, yet the skin should be kept in the yellow-orange range. Highlights can be worked in pale yellow, beige cream, or white for the nose ridge, the top of the chin, and the top of the cheek areas. Medium shadows are created using deep chrome orange, 80% French gray, and chocolate brown. Because this skin colors starts with a deep tonal value of yellow, to establish the darkest shadows you will be using black cherry, red-purple, and even indigo blue. Just as with pale skin, try using Venetian red and deep orange for your blush tones. To give a final blending throughout the face use 80% French gray, burnt umber, or copper brown.

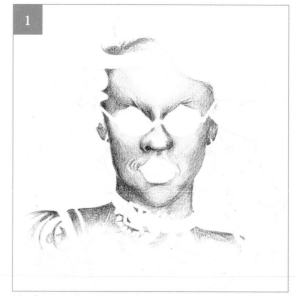

The first shading layers of *Dark Moon Rising* use black cherry as the mid-range tone, indigo blue for deep values, and copper brown as the brighter pale value.

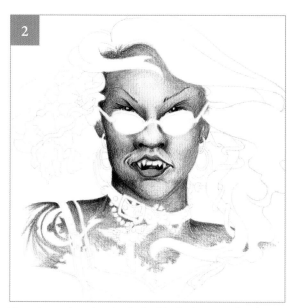

Venetian red pushes both the black cherry and indigo blue work closer to a deep orange. Several layers of golden sienna are used over the entire face to blend all of these early shading colors.

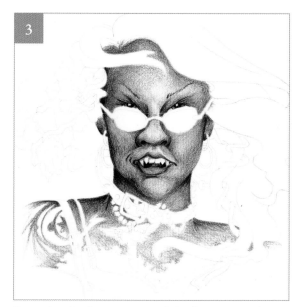

Repeating the first two steps of shading tones and blending color begins to bring some intensity to the color development.

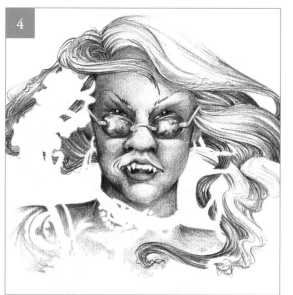

Venetian red and deep chrome orange adds the blush areas to the face. Several shades of french gray, indigo blue, and Venetian red are added into the hair. The sunglasses use deep red-purple, hot pink, and carbon black.

UNANSWERED VAMPIRE QUESTIONS Does a vampire eat solid food? A Bloodburger? Can a vampire get drunk and if they can do they get drunk from certain blood types?

5

Dark skin coloration can range from chocolate brown tones to soft deep beige. To push *Dark Moon Rising* closer to the chocolate range, several coats of 50% French gray have been worked over the entire face, including the blush areas. Black cherry and deep vermillion are her lip colors, with a dark brown for the eyes and eyebrows. The hair flowers and metal in the eye glasses and earrings are shaded with several layers of chrome yellow, deep chrome orange, and copper beech.

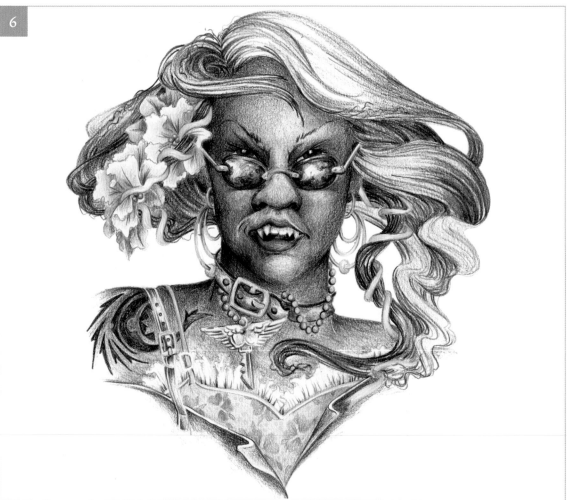

6

A layering of sepia brown is the final blending color, with titanium white used on the highlights. In the dark skin tone chart, you will note how far into the orange range the dark skin coloration falls. To balance that orange range, deep chrome orange and crimson lake have been used in the hair flowers and clothing.

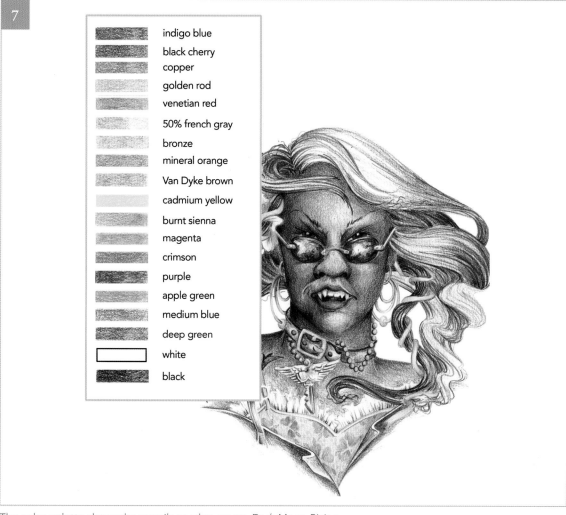

	indigo blue
	black cherry
	copper
	golden rod
	venetian red
	50% french gray
	bronze
	mineral orange
	Van Dyke brown
	cadmium yellow
	burnt sienna
	magenta
	crimson
	purple
	apple green
	medium blue
	deep green
	white
	black

The color palette shows the pencils used to create *Dark Moon Rising*.

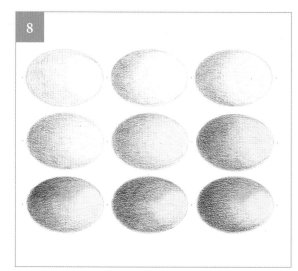

This chart shows the basic progression of colors used to develop a dark skin tone effect.

vampire facts

One of the earliest accounts of vampires is found in an ancient Sumerian and Babylonian myth dating to 4,000 B.C.. The account describes ekimmu or edimmu (one who is snatched away). The ekimmu is a type of uruku or utukku (a spirit or demon) who was not buried properly and has returned as a vengeful spirit to suck the life out of the living.

Bartlett, Wayne and Flavia Idriceanu. 2006. *Legends of Blood: The Vampire in History and Myth*. Westport, CT: Praeger Publishers.

Applying Colored Pencils to Your Vampire Drawings

Multiple thin, gently applied layers of pencil create the final intensity of your work. Keep your pencil points well sharpened and use as light a pressure on the point as possible. Use several colors, layered one over another, to create new colors in place of using just one color. Add layers of white, 20% French gray, or soft cream to create paler tones and use carbon black, black cherry, and indigo blue to push your colors into shadow tones. Do not hesitate to use unrelated or unexpected hues in one area of the work. As an example, adding a layer to two of bright cadmium yellow to a skin highlight can create a shock-value or surprise effect to a cheekbone or to the top of the chin.

OPPOSITE: The first shadow tones established for *Gray Ghost* were worked in black cherry instead of a dark brown such as Van Dyke. As more skin colors are applied, the black cherry will provide a mulberry brown tone that will show through the later skin colors. At this stage in the work, the portrait has about four to five very thin layers of pencil work. See pages 78 and 79 to see how to apply the next layers of color.

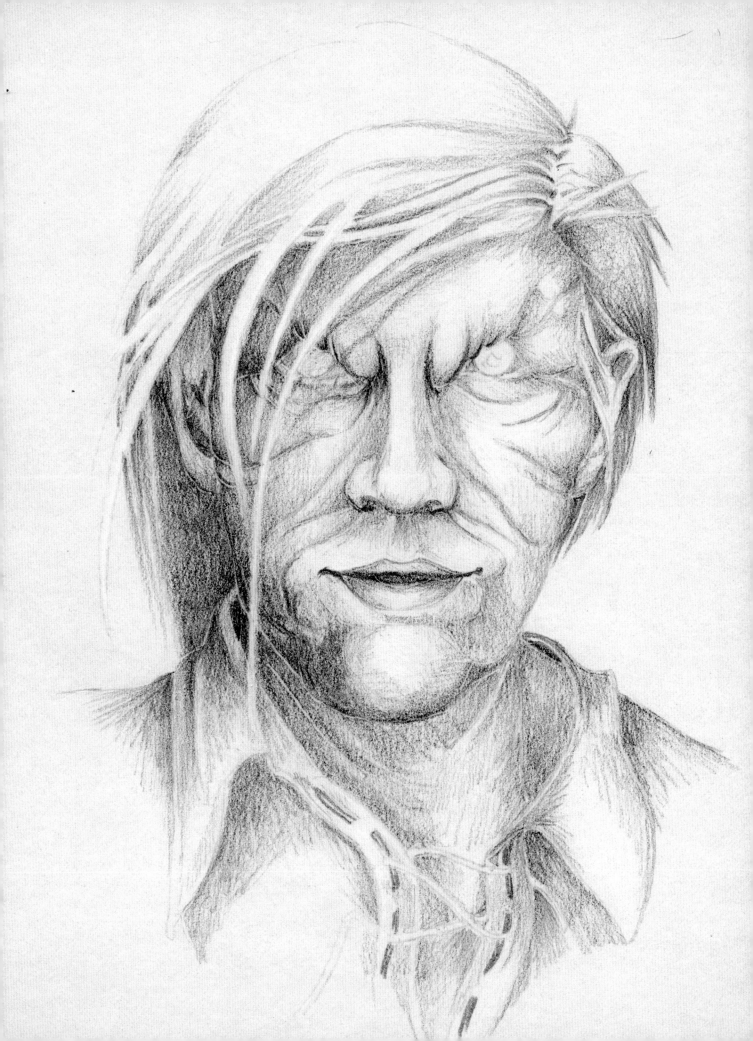

Layers

On average, a well-worked portrait can easily have twenty or more layers of color. Each layer of work goes quickly and an average portrait might be completed within a few hours. The first layers of your portrait are the most important because they are used to establish the deepest shadows of the face. Keep these layers extra thin so they can quickly be adjusted to increase or decease any particular shadow.

Eventually the colored pencil work will not accept any new layers because of the wax or chalk build up that comes from the type of pencil you use. You will see a slight sheen developing on the surface of the work as you near this point. Chalk-based hobby pencils reach the non-acceptance point faster than artist-quality pencils.

If you have reached the non-acceptance point before you have completed your shading when using wax-based or watercolor pencils, lay a sheet of facial tissue over the artwork. Gently pat the tissue against the colored pencil work. The tissue will pick up and remove some of the wax, allowing you to apply a few more layers of color.

You can use an artist's kneaded eraser to gently lift the chalk build-up from hobby quality pencils. Kneaded erasers also will lift areas that have become too dark too quickly. Gently press and lift the eraser against the color area. Kneaded erasers can be pulled, twisted, and shaped, so you can even use a thin edge of a kneaded eraser to work pale highlight lines into you portraits.

Mistakes happen! When yours comes along, take a small piece of transparent tape and gently lay the tape over the error. Do not push the tape against the paper, instead use a sharpened pencil or pen and work a few lines on top of the tape where the error lies. When you lift the tape only those areas that have been worked with the pen will have the coloring removed.

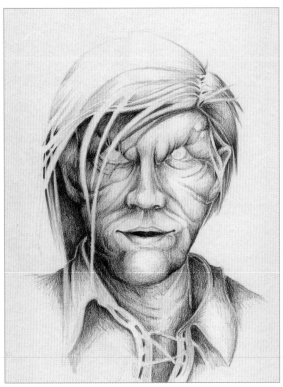

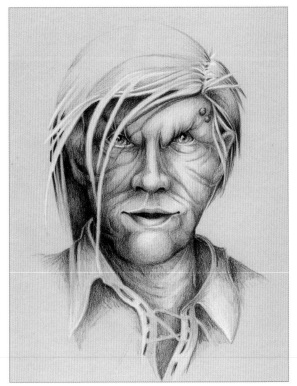

Indigo blue has been added to create even more shading within his face. A few areas of cadmium yellow were added around the mouth, beneath his chin, and along the sides of his face.

Only a few areas of a medium dark brown skin tone have been used at this point—in the neck, the ball of the chin, and at the sides of the cheeks. Approximately ten layers of colored pencils have been used at this point.

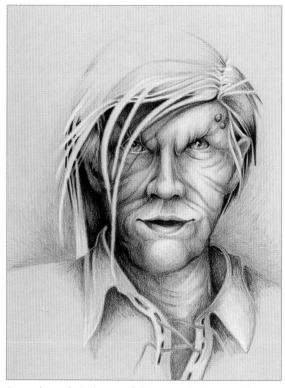

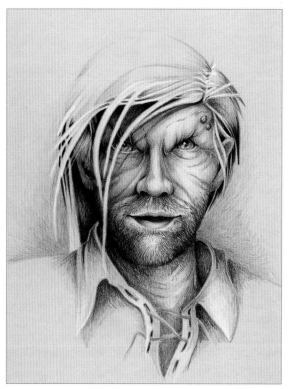

Several very light layers of deco peach alternated with titanium white over the face areas begin to blend the black cherry, indigo blue, and cadmium yellows into skin colors. A golden ocher hue has been added to the face where it is shadowed from the hair and collar. Approximately four to five new layers of pencil have been added.

With the additions of carbon black and indigo blue for the beard stubble and deepest shadows, *Gray Ghost* becomes far more interesting with its varying colors than it would have been worked strictly in shades of beige through brown. *Gray Ghost* was worked on medium gray lightly toothed illustration paper. The gray tone of the paper has become part of the skin coloring for this vampire. The medium tonal value of the paper makes the titanium white highlights stronger and therefore more dramatic. The final portrait may have as many as 20 to 25 layers of pencil work.

vampire facts

Vlad of Walachia, a.k.a. Vlad the Impaler (c. 1431–1476), is the likely source for many vampire legends. His favorite pastimes including nailing hats to people's heads, skinning them alive, and, of course, impaling them on upright stakes. He also liked to dip bread into the blood of his enemies and eat it. His name, Vlad, means *son of the dragon* or *Dracula*. Though Vlad the Impaler was murdered in 1476, what was believed to be his tomb was exhumed for research purposes in the early 1900s and was reportedly found to be empty.

Melton, J. Gordon. 1999.
The Vampire Book: The Encyclopedia of the Dead.
Farmington Hills, MI: Visible Ink Press.

APPLYING COLORED PENCILS TO YOUR VAMPIRE DRAWINGS

UNANSWERED VAMPIRE QUESTIONS If you are a vampire and don't have a grave or weren't buried in a crypt, how do you find housing?

Selecting Colored Pencils

Colored pencils are a favorite medium for new portrait artists. They are inexpensive and available in six, twelve, twenty-four and even large sets. Pencils come in several varieties and color quality—hobby colors, dry artist colors, and artist watercolors. What you chose depends on both the financial investment you wish to make and your style of art. All three varieties can be used together on the same piece of art.

The greatest advantage of colored pencils is their ease of use. They require no special mixing medias, no brushes, never bleed outside the lines, and can be used on substrates such as watercolor paper, bristol board, chip board, wood, and even fabric.

Hobby-quality colored pencils are available, usually in sets, at many local craft stores and office supply stores. The most inexpensive, they have a chalk base to the pencil core and tend to have a harder density to the pencil core.

Artist-quality colored pencils come in two main varieties—wax based pencils and watercolor pencils. The waxed-based pencils are very transparent, allowing you to mix layers of different pencil colors to create new colors. This style of pencil has a soft core making color application smooth and even. Watercolor pencils are applied dry, then moistened with a damp brush to create painting effects. Both watercolor pencils and dry artist pencils are available by set or by individual color either online or at your larger arts and crafts outlets. Watercolor pencils can be left in the dry stage just as wax based pencils.

A basic starter set might include: medium pink, cadmium red, light orange, cadmium orange, light yellow, cadmium yellow, light green, medium green, light blue, ultramarine blue, lavender, and purple. This provides all of the primary and secondary colors.

To this set you may want to add five basic shading or tonal value colors: titanium white, carbon black, 50% french gray, black cherry, and indigo blue.

Specific colors for portrait work include: deco peach, mulberry, copper beach, and yellow ocher. Several manufacturers have specific colored pencil sets for portraiture.

Blending pencils, clear wax based pencils, are available and used over a color mix to remove pencils lines and create a more even effect to the pencil work.

With your colored pencils you will also need a good pencil sharpener, a white artist's eraser, an artist's kneaded eraser, transparent tape, and a variety of papers. Heavier weight papers are preferred; thin papers do not have the strength to carry multiple layers of pencil color. Watercolor papers with a fine tooth (texture), illustration paper, bristol board, and even heavyweight drawing paper work well. Some artists' papers come in a range of color tones from soft cream through deep brown and including black. Using a colored paper as your substrate automatically provides a colored background to your work. Avoid heavily toothed paper and polished (shiny) paper while you are learning the use of your pencils.

medium pink
cadmium red
light orange
orange
light yellow
cadmium yellow
medium green
green
medium blue
ultramarine blue
lavender
purple

titanium white
carbon black
50% French gray
black cherry
indigo blue

Twelve colors create a full hue palette and unlimited mixing potential for new colors. Adding five basic shading tones gives an even wider range for highlights and shadows.

Patterns

Open Grave

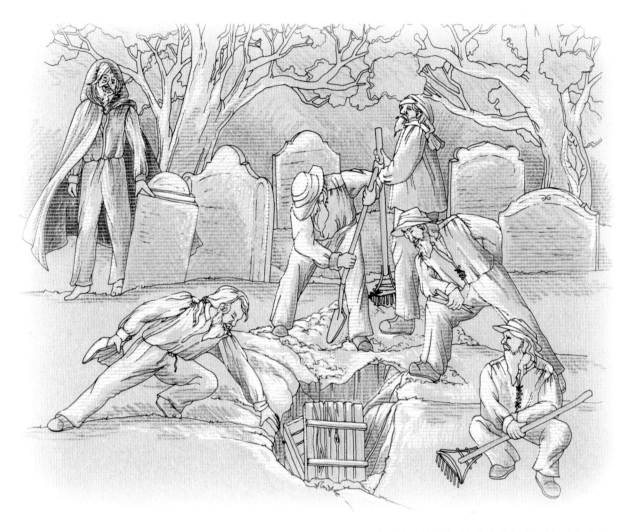

Anger

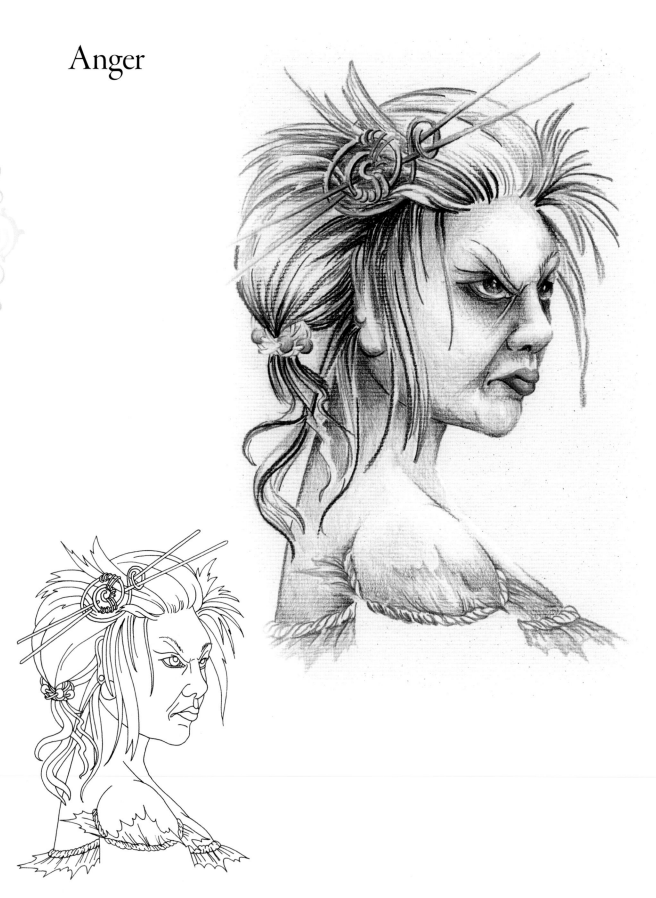

Attitude

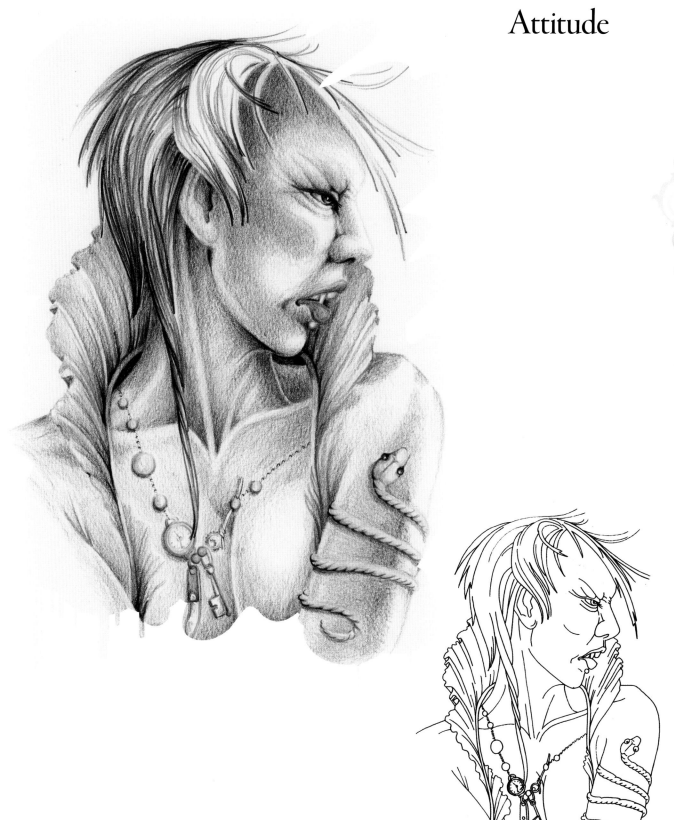

Basic Vampire

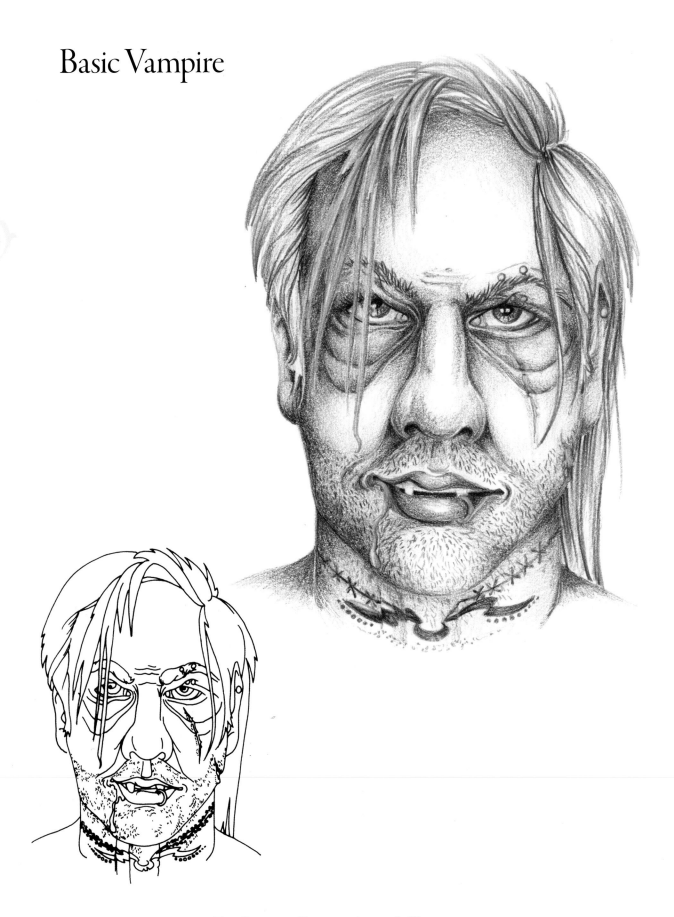

Bat Wings

Black Bride

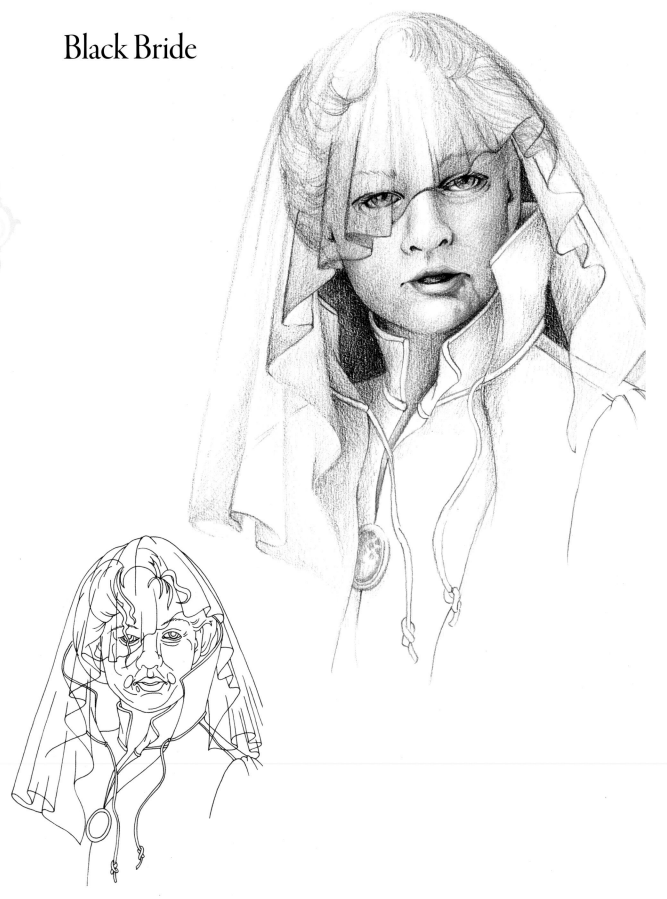

Black Satin

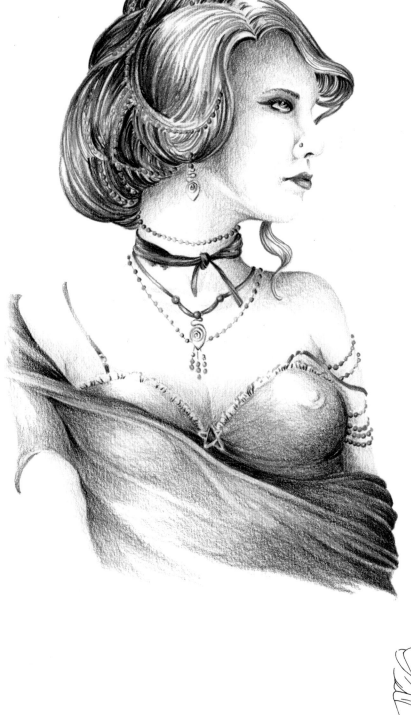

Blood Lust

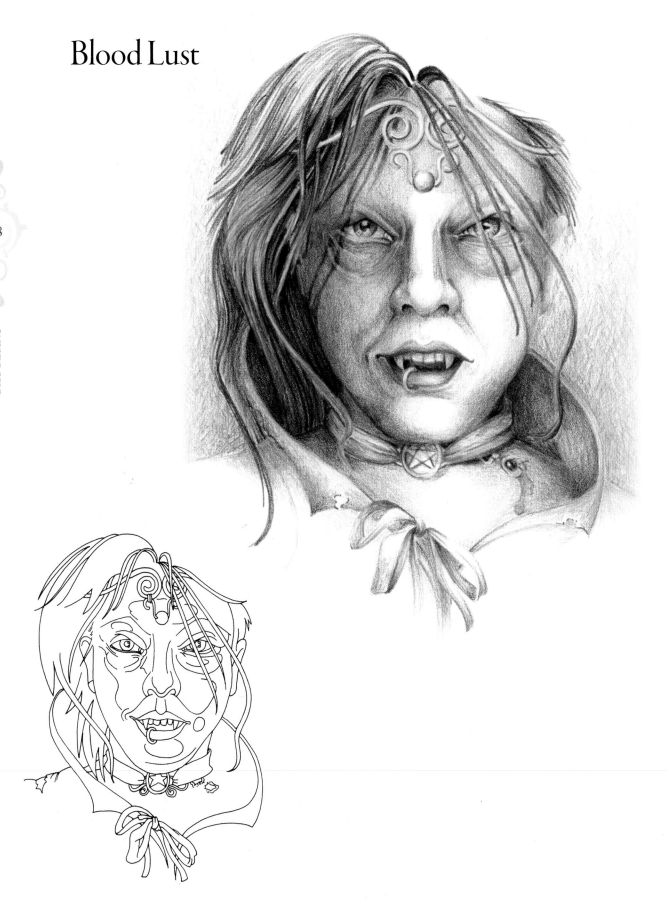

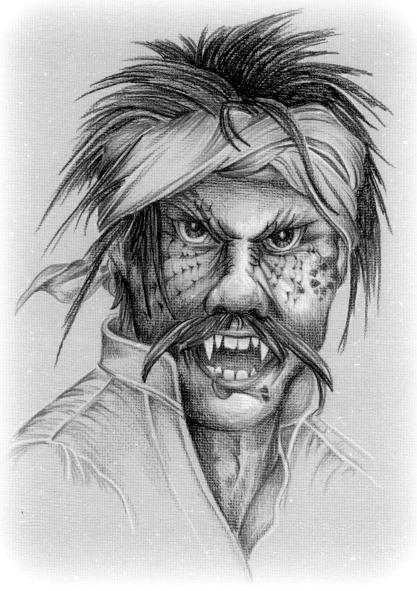

Blood Rage

Bullet Hole

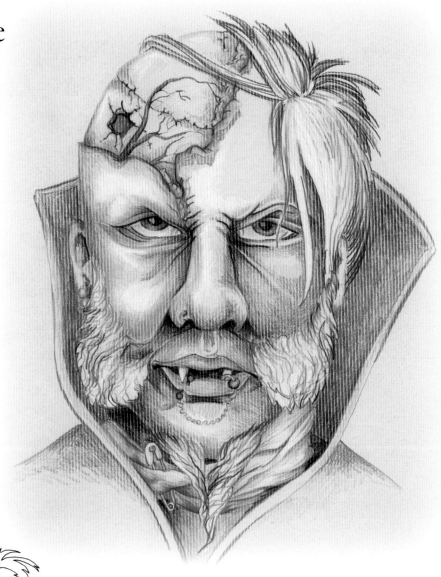

Dark Moon Rising

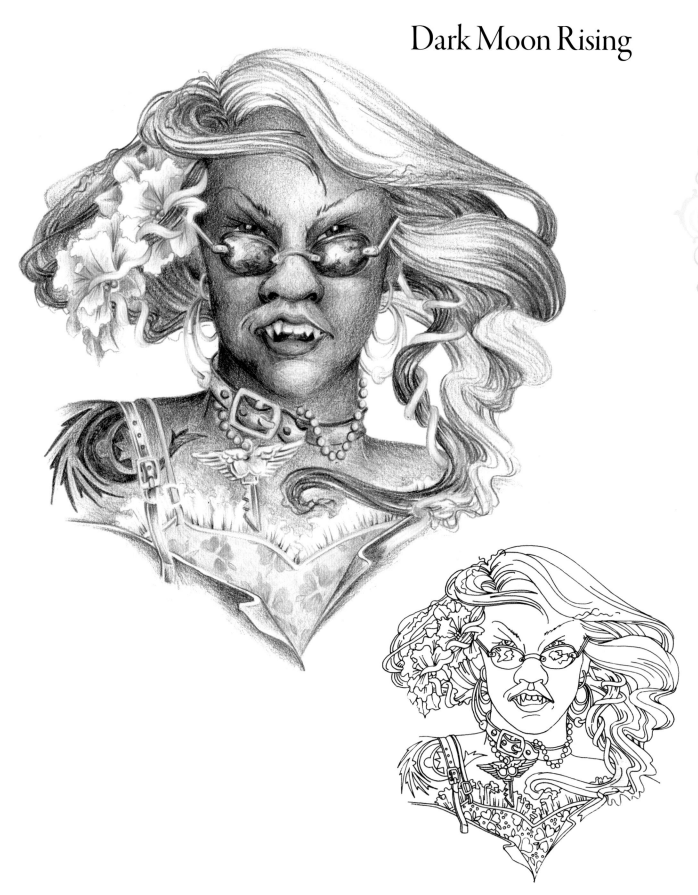

Happy Demon

Knots

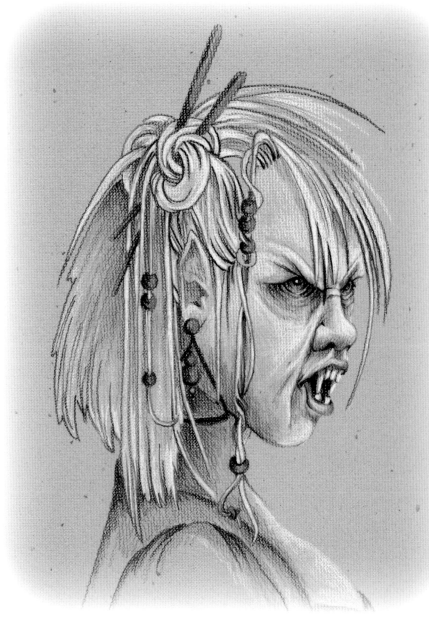

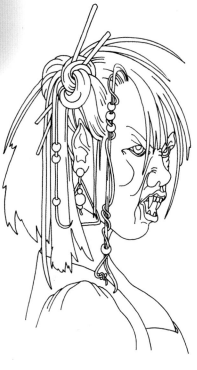

Leather

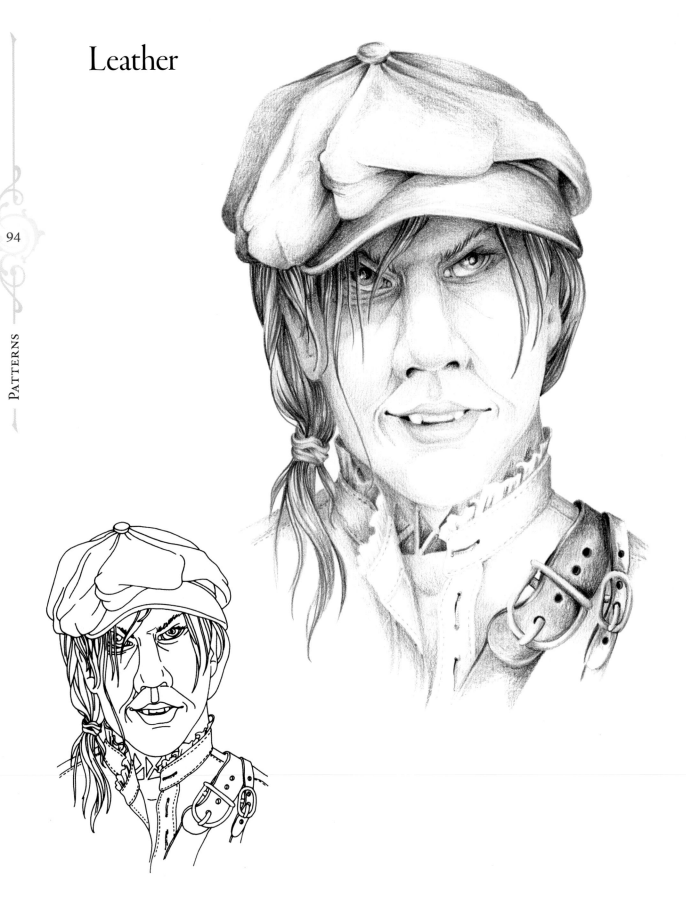

Long Slumber

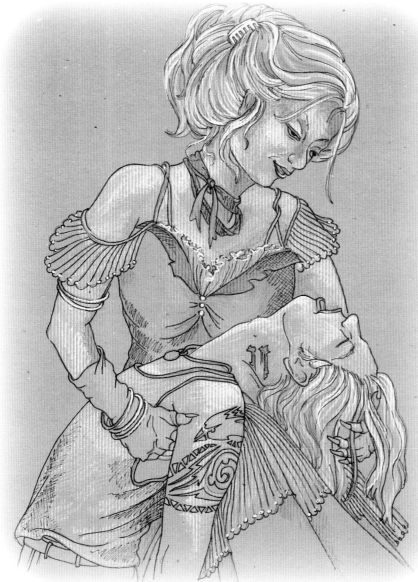

Night Owl

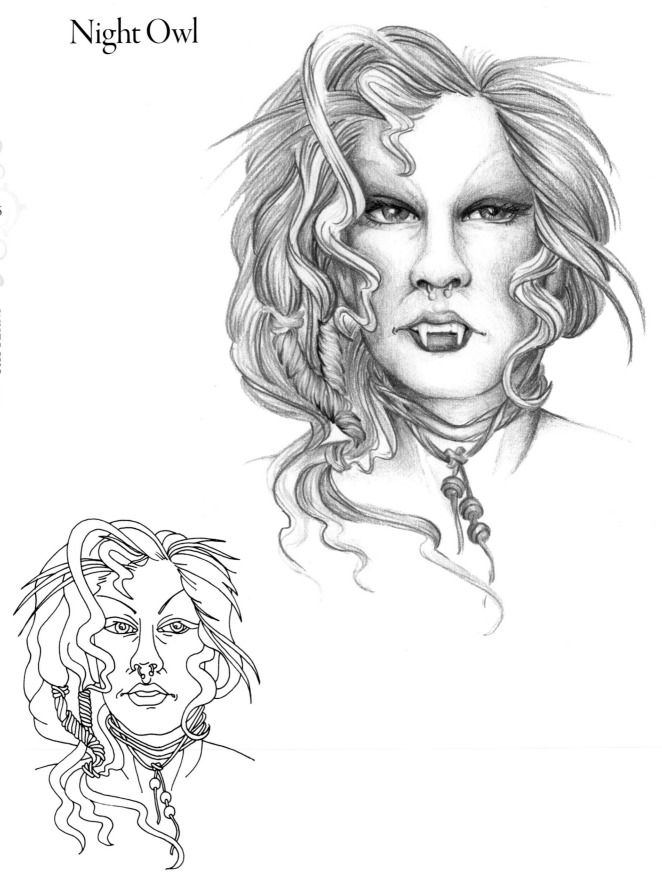

High School Yearbook Photo Sample

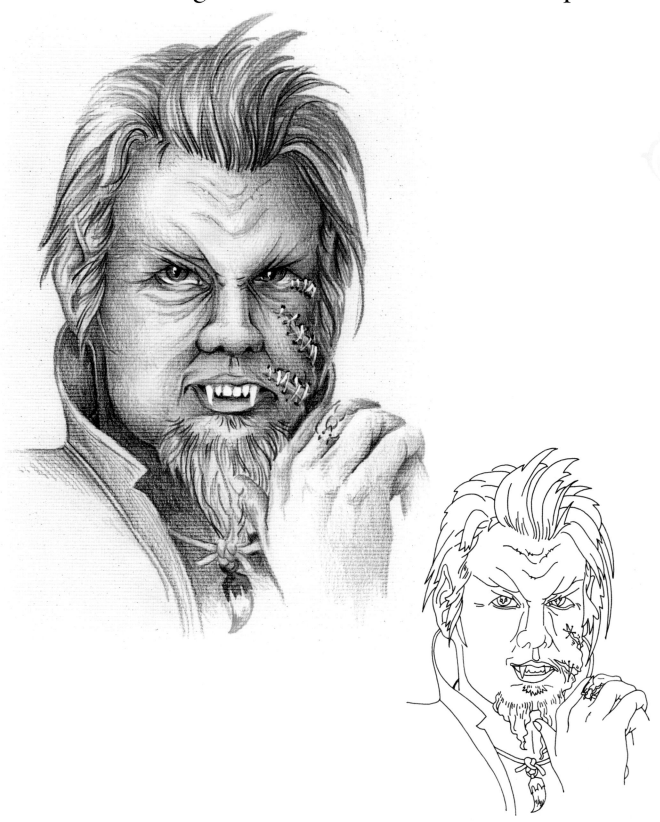

Pretty in Pink

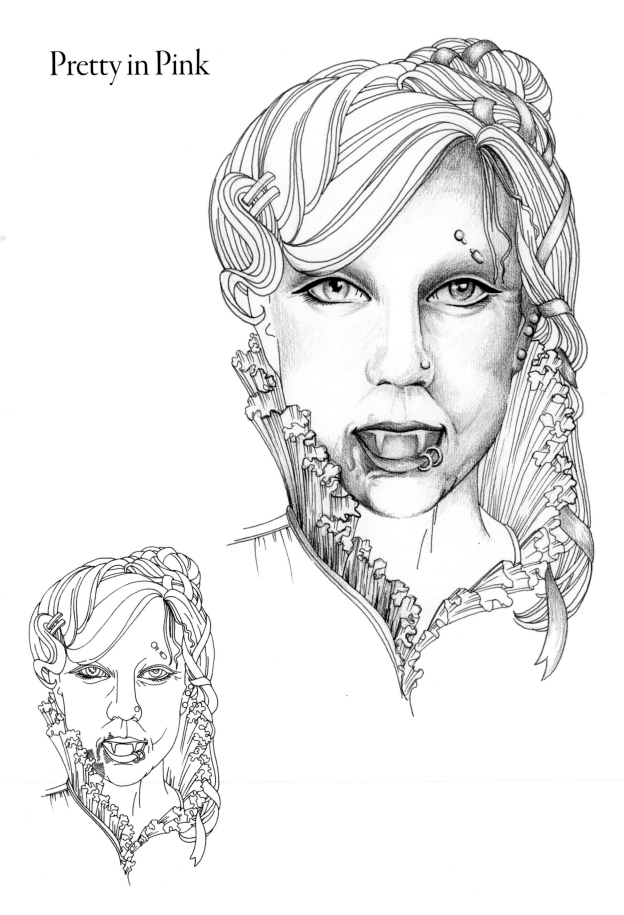

Raven

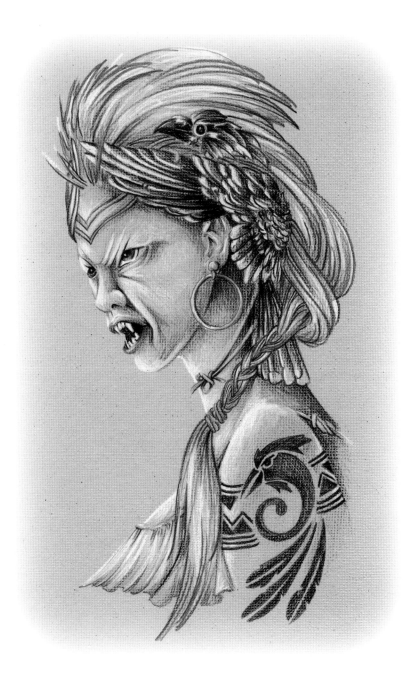

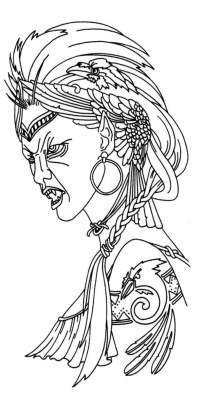

Shadows

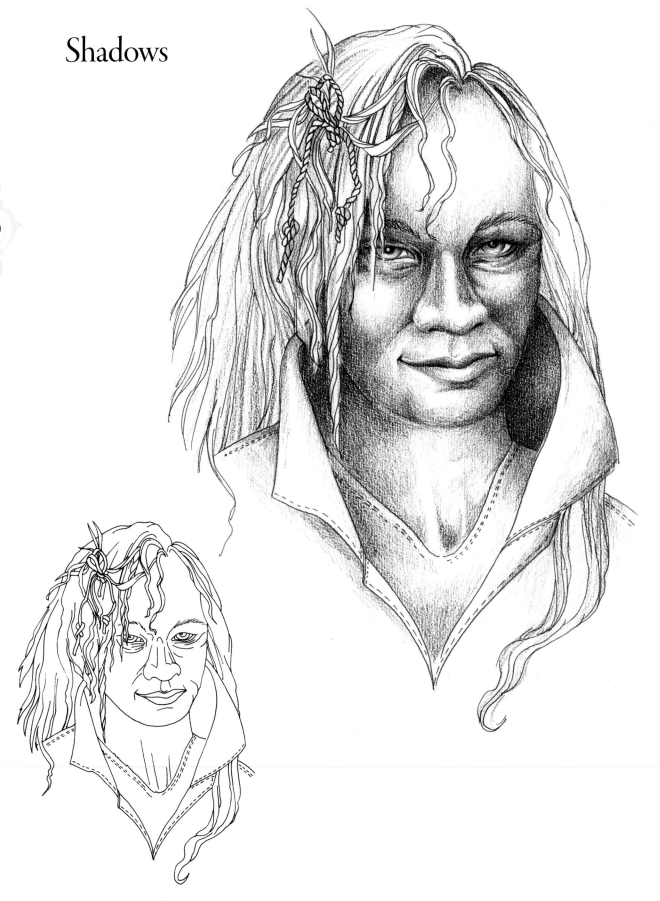

Steampunk

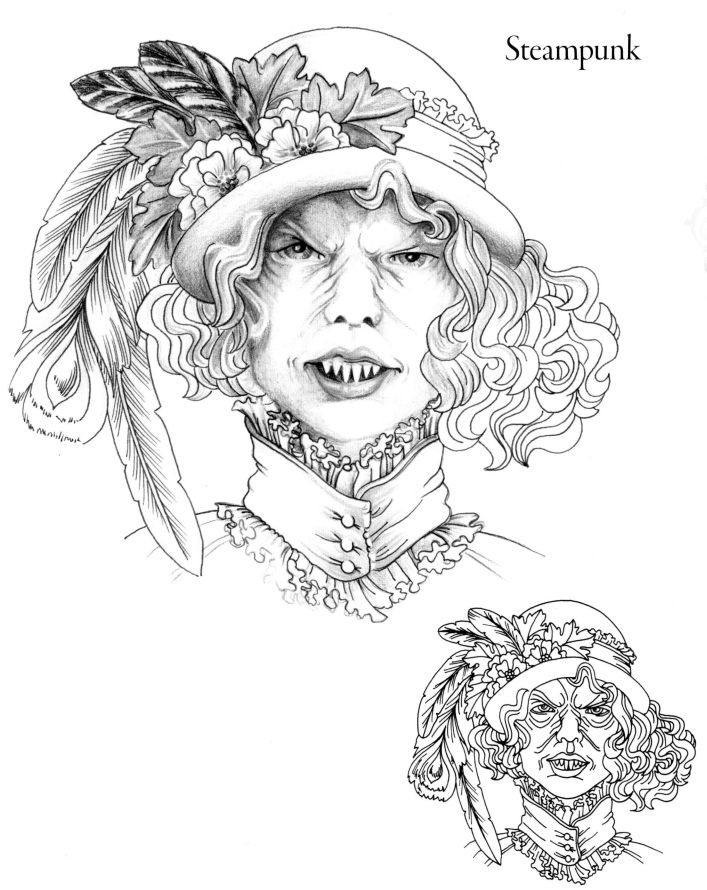

The Good Reverend

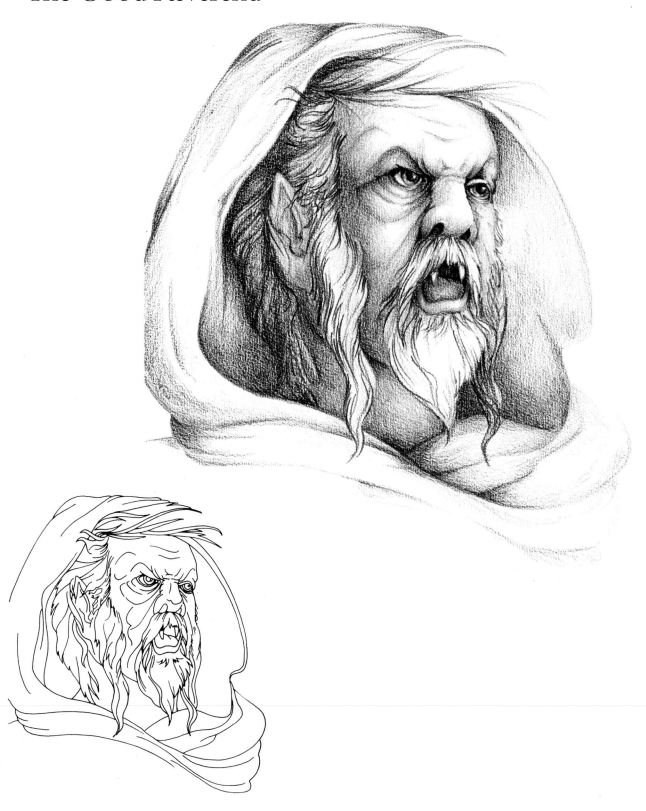

The Matron

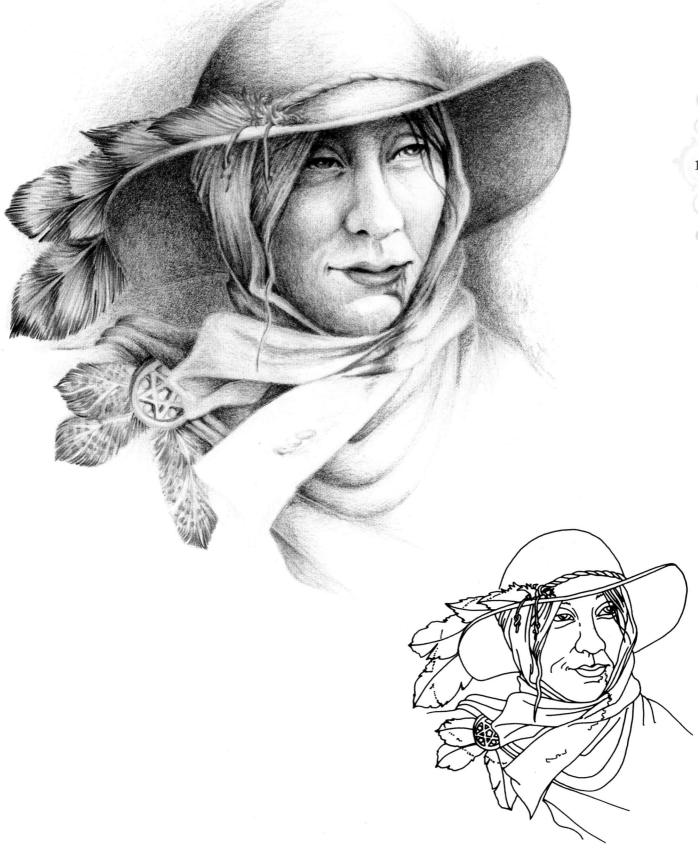

The Professor

The Street Merchant

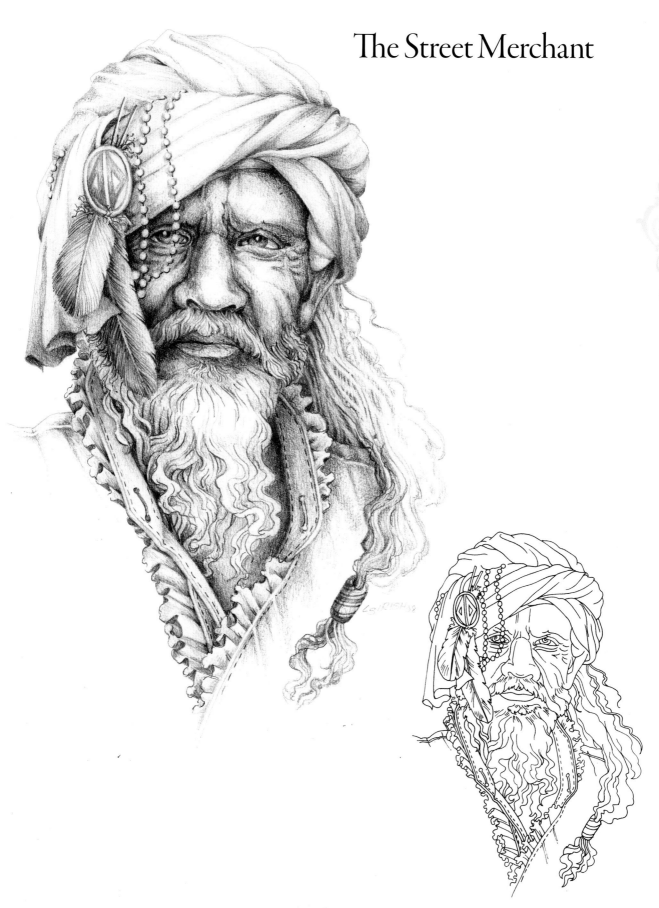

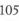

Thinly Veiled

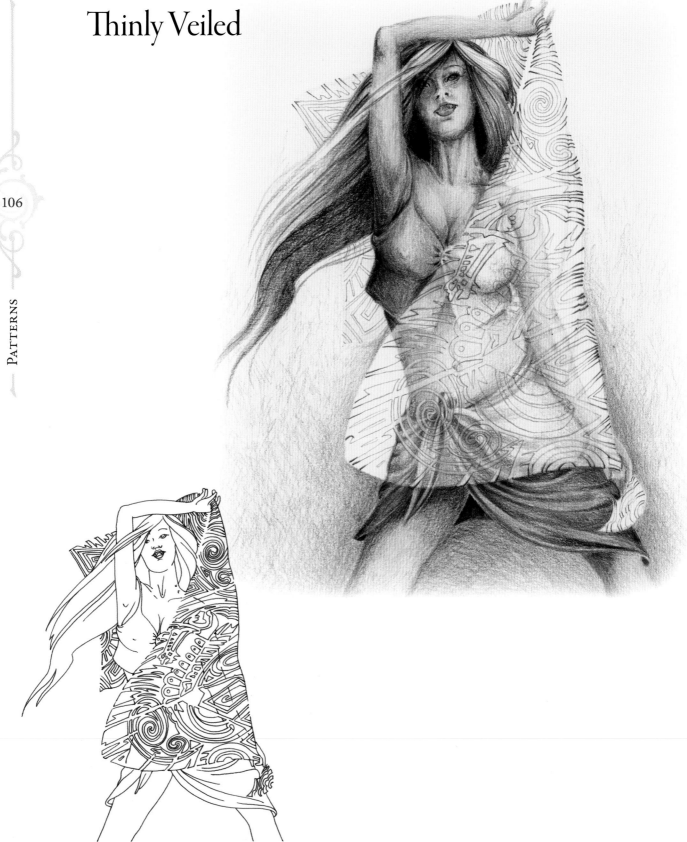

Three Days Dead

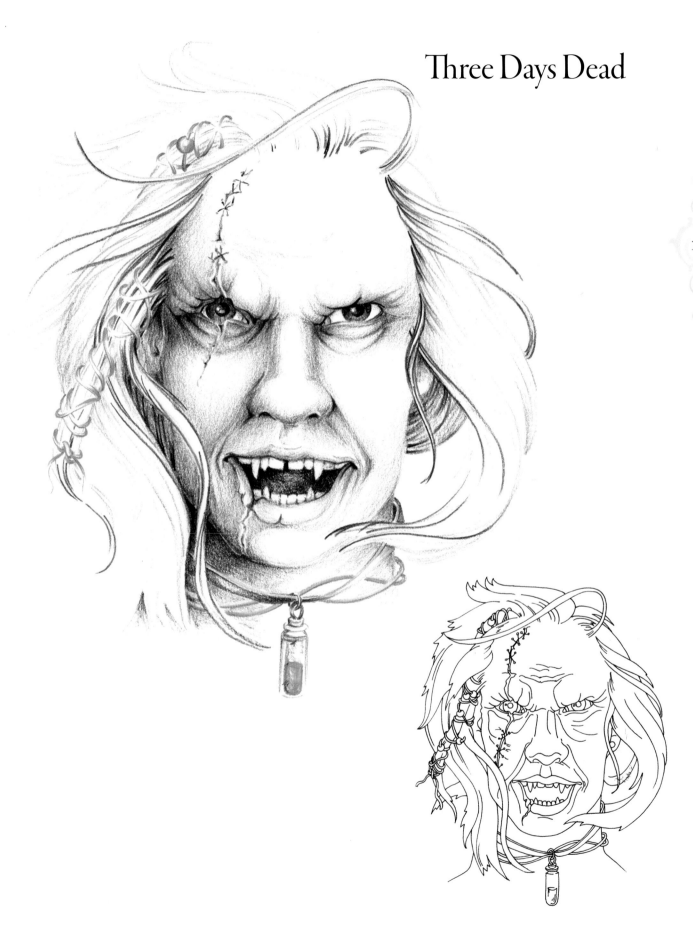

The Tombstone

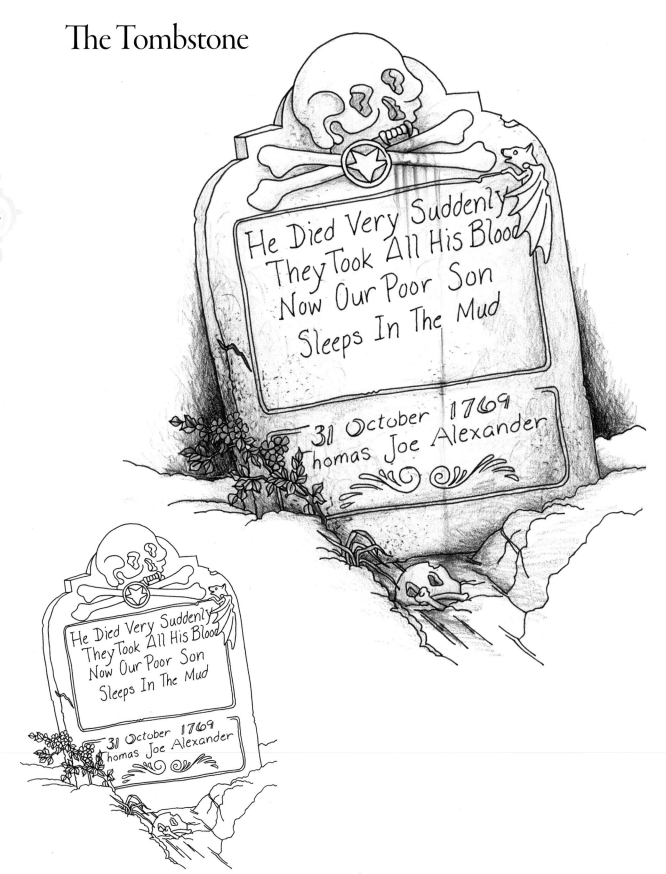

He Died Very Suddenly
They Took All His Blood
Now Our Poor Son
Sleeps In The Mud

31 October 1769
Thomas Joe Alexander

Viking King

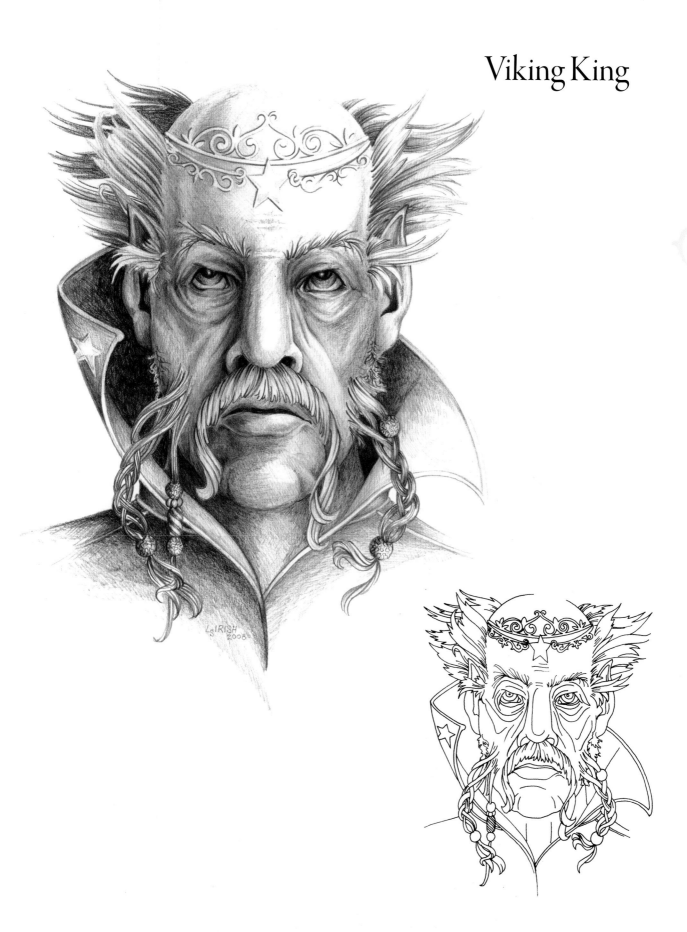

Wind Swept

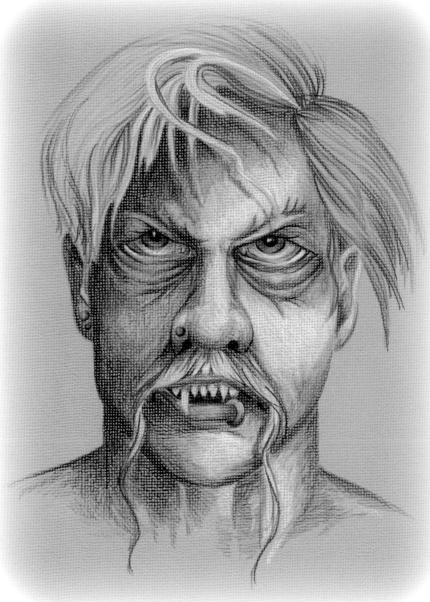

Index

ACQUISITION EDITOR: PAUL M. HAMBKE DESIGNER: JASON DELLER DEVELOPMENTAL EDITOR: PAUL M. HAMBKE
PHOTOGRAPHER: LORA S. IRISH COPY EDITOR/PROOFREADER: LYNDA RUNKLE

Great Book of
Fairy Patterns
*The Ultimate Design Sourcebook
for Artists and Crafters*
By Lora S. Irish

Bring the magic of fairies to your art.
Dozens of original fairy patterns, along
with tips and techniques for artists and
craftspeople working in all mediums.

ISBN: 978-1-56523-225-9
$22.95 • 192 Pages

Great Book of
Tattoo Designs
More Than 500 Body Art Designs
By Lora S. Irish

Features more than 500 line and shaded
body art designs, perfect for adorning
craft projects. Topics include fantasy, floral,
wildlife, symbols, and more.

ISBN: 978-1-56523-332-4
$16.95 • 504 Pages

Great Book of
Celtic Patterns
*The Ultimate Design Source
for Artists and Crafters*
By Lora S. Irish

Unravel the secrets to creating knotwork
as you adorn your projects with beautiful
twists, braids, and textures. The essential
Celtic design reference! Features 200
original patterns.

ISBN: 978-1-56523-314-0
$22.95 • 200 Pages

Modern Tribal
Tattoo Designs
By Lora S. Irish

Ready to be replicated by your tattoo artist
or personalized for your next craft project,
this collection of modern tribal patterns
include bold black lines, spiked spirals,
curved lines, barb-wire, and more.

ISBN: 978-1-56523-398-0
$14.95 • 152 Pages

Great Book of Dragon
Patterns, 2nd Edition
*The Ultimate Design Source
for Artists and Crafters*
By Lora S. Irish

This second edition on creating renderings
of the mighty dragon includes more than
100 original patterns and a color reference
chart; features dragon anatomy, historic
legends, and much more.

ISBN: 978-1-56523-231-0
$22.95 • 188 Pages

Easy & Elegant Beaded
Copper Jewelry
*How to create beautiful fashion
accessories from a few basic steps*
By Lora S. Irish

Make your own affordable and stylish
copper wire jewelry with a few simple
tools, some wire, and beads.

ISBN: 978-1-56523-514-4
$24.95 • 256 Pages

Great Book of Floral
Patterns, 2nd Edition
*The Ultimate Design Source
for Artists and Crafters*
By Lora S. Irish

More than 100 stunning floral patterns to
adorn your next project. Includes a guide
to identify floral shapes and create realistic
shading.

ISBN: 978-1-56523-447-5
$24.95 • 216 Pages

101 Artistic Relief
Patterns for Woodcarving,
Woodburners & Crafters
By Lora S. Irish

From celebrated artist Lora S. Irish comes
a treasure trove of small and beautiful
patterns for crafters of all mediums.
Perfect for carving, woodburning, painting
and more.

ISBN: 978-1-56523-399-7
$19.95 • 122 Pages